IMAGES
of America

LITTLETON
NEW HAMPSHIRE

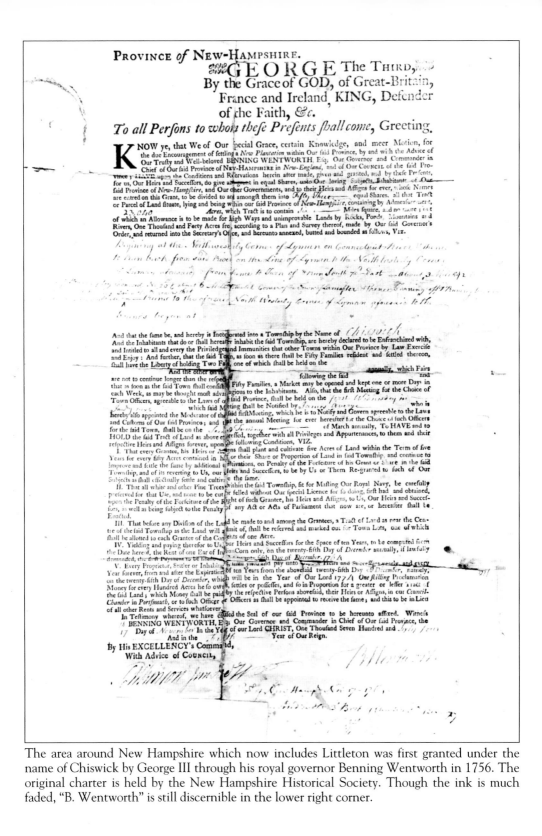

The area around New Hampshire which now includes Littleton was first granted under the name of Chiswick by George III through his royal governor Benning Wentworth in 1756. The original charter is held by the New Hampshire Historical Society. Though the ink is much faded, "B. Wentworth" is still discernible in the lower right corner.

IMAGES
of America

LITTLETON
NEW HAMPSHIRE

Arthur F. March, Jr.
from the collection of the Littleton Area Historical Society

ARCADIA
PUBLISHING

Copyright © 1995 by Arthur F. March, Jr.
ISBN 978-0-7385-6441-8

Published by Arcadia Publishing
Charleston SC, Chicago IL, Portsmouth NH, San Francisco CA

Printed in the United States of America

Library of Congress Catalog Card Number: 2009921957

For all general information contact Arcadia Publishing at:
Telephone 843-853-2070
Fax 843-853-0044
E-mail sales@arcadiapublishing.com
For customer service and orders:
Toll-Free 1-888-313-2665

Visit us on the Internet at www.arcadiapublishing.com

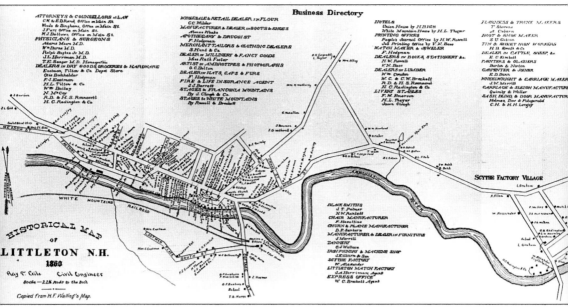

A map and business directory prepared by Ray T. Gile in 1860 indicates the quite remarkable enterprise of the townspeople. No less then twenty-seven different occupations are listed and in many cases one person had several. Witness F. Hodgman who was not only an apothecary and druggist but dealt in beaver hats and furs and was a watchmaker and jeweller as well. Josiah Kilburn's Iron Foundry housed two sons who would eventually make the town internationally known for the manufacture of stereoscopic view cards. The scythe factory was of such importance that the east end of town was known as "Scythe Factory Village." Littleton was also the eastern terminus of the White Mountain Railroad.

Contents

Acknowledgments

For the help I have received in making this compilation I am indebted to many but must especially express my appreciation to Dr. Richard L. Hill, president of the Littleton Area Historical Society, 1989–94; Frances Heald, Barbara Hill, and Lester Goad, coordinators of the Littleton Historic Museum; Horace Burrington, Shirley Burrington, Marguerite Clark, Linda McShane, and Jean Musgrave, my coworkers on the committee which has catalogued and preserved the photograph and stereograph collections over a period of four years (and are still at it); and finally, to my wife, who after fifty-three years is still correcting me.

IN MEMORY OF THE
REVOLUTIONARY PATRIOTS OF 1776
WHO ENLISTED TO DEFEND
THE NORTHERN FRONTIER
AND ALSO TO MARK
THE SITE OF THE FIRST HOUSE
AND BIRTHPLACE OF THE
FIRST WHITE CHILD BORN IN TOWN
APRIL 12, 1770
ERECTED BY
THE ELLEN I. SANGER CHAPTER
DAUGHTERS OF THE AMERICAN REVOLUTION
1905

The First Settlers

As the French and Indian War gradually subsided after the fall of Quebec in 1759, settlers began pushing their way north into undeveloped territory. The broad Connecticut River and the many Indian trails that flanked it made a natural corridor into the wilderness that lay north of Fort #4 at Charlestown. At the Haverhill-Bath line the Connecticut is joined by the Ammonoosuc, and settlements naturally spread in this direction. Up-river from Bath, Lisbon was chartered in 1761—first as Concord, later as Gunthwait—and a stockade was built here for protection against bands of marauding Indians, who not unnaturally resented this incursion on territory they had roamed for generations. Beyond Gunthwait the Ammonoosuc runs through broad fertile meadows and this desirable area between the diverging rivers was chartered in 1764 under the name of Chiswick.

It was along this rough trail following the rivers that Nathan Caswell and his family packed all their belongings on a single horse and, in the spring of 1770, left the settlement of Orford. After traveling through Piermont and Haverhill to Bath, they followed the Ammonoosuc and eventually reached Gunthwait. Caswell and his eldest son had been over the trail the previous year and knew of the existence of a small hut on the meadow near the riverbank. Arriving at this goal, the family found to their dismay evidence of recent Indian visits and spent what can only be imagined as an anxious night. The boys slept outside in the long meadow grass; Mrs. Caswell retired to the hut and proceeded to increase Littleton's population by one—her fifth son. In the morning, they decided to retreat to the safety of the Gunthwait stockade, so Nathan and his sons hewed out a rough dugout canoe in which the family floated downriver while the oldest boy, a manly eight years of age, rode or led the horse back the way they had come. After a few days this indomitable family returned to their "home" to find the cabin burned and what few goods they had left stolen. Is it credible that they set to work on a new cabin, cleared and planted a small garden, and became the first family in Littleton? They did.

About Photographs and Photographers

The technique of capturing an image formed in a camera by a convex lens and preserving it on paper or some other medium was presented to an astonished and intrigued world in 1839. Two radically different processes were introduced by two men working independently in two different countries (England and France). At first the French process, named after its inventor Daguerre, was by far the more popular; it crossed the ocean with astonishing speed and by 1850 huge, glamorous "daguerreotype" studios mushroomed in Boston, Philadelphia, New York, and other American and Canadian cities. Despite the relatively high cost, people rushed to have their likeness preserved on these small pieces of silver-coated copper mounted in elaborate cases.

The other process, developed by Talbot in England, was slow to catch on but when the early problems were overcome it rapidly became the dominant process and has remained so for the last 150 years. Recently, electronic imaging has come to the fore and will soon make the Talbot process as rare as Daguerre's is today.

The town of Littleton attracted early photographers, not only because its citizens shared the universal urge to have their images preserved, but also because of its remarkable natural scenery which, through the miracle of photography, could now be viewed by anyone, anytime, anywhere. As early as 1847 we have records of itinerant photographers visiting the area in their horse-drawn wagon darkrooms. The 1860 map and business directory on p. 4 lists one O.C. Bolton, "Artist in Ambrotypy," as an established business. (The ambrotype was a later development of the daguerreotype and is frequently confused with it although the processes are very different.) Beginning with Bolton, the town has been generously supplied with "artists in photography," and as we shall see, a specialized form of photograph, the stereograph, would have a remarkable impact on the economy of the area. Many of these early photographers are represented in this collection and wherever possible we have identified them and the process they used.

One

Industry, Business, the Arts, and Professions

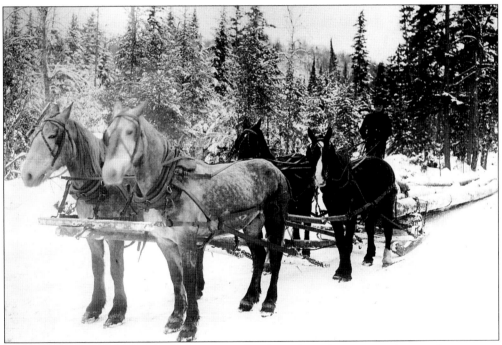

Wood was the wealth of the North Country and to the early settlers it was truly an embarrassment of riches. Land had to be cleared for the planting of crops and while the wood itself supplied homes, furniture, tools, and utensils in astonishing variety (and, of course, was the only source of heat), much of it was simply burned to get rid of it. The axe was as necessary to the settler as his gun and the ring of steel on hardwood in virgin forests was the sound of a new civilization. The horse was also a vital element in the operation to drag the enormous logs to the building site or, later, to the sawmills which quickly appeared along the banks of the two rivers and streams in the area. William Knapp is the logger shown here. (Albumen print, mounted; Hall Studio, Ltn.)

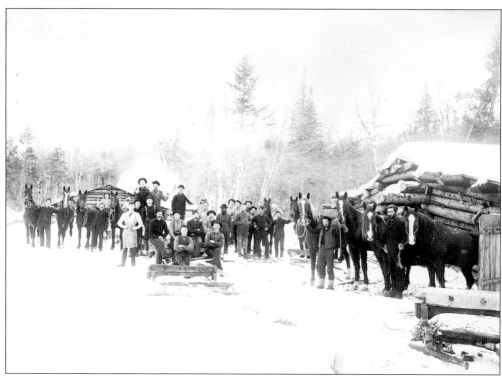

With the growth of the settlements and the increase in the number of sawmills, the demand for boards grew rapidly, and logging became the area's first industry. Most of the logging was done during the winter because dragging out the enormous logs was easier on ice and snow. (Albumen print, mounted.)

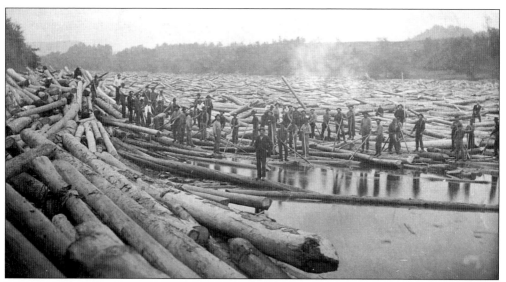

In spring the rivers served as a convenient method of transport—convenient in the sense that there was no other. Scenes like this jam on the Connecticut were common. One wonders what life insurance premiums would be for work like this.

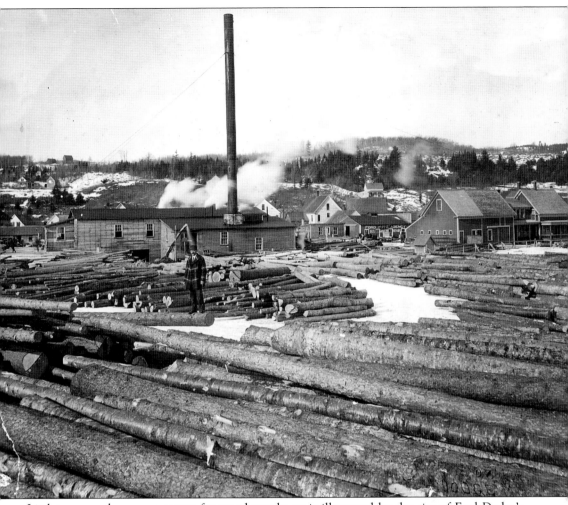

Littleton soon became a center for wood supply, as is illustrated by the size of Fred Dodge's operation in Apthorp (at the east end of town). Not only was lumber supplied as boards and timbers but these businesses eventually expanded into providing dimension lumber and finished millwork for homes far removed from the primitive log cabins of the early settlers, and in some ways, unmatched by the houses of today. (Albumen print, mounted.)

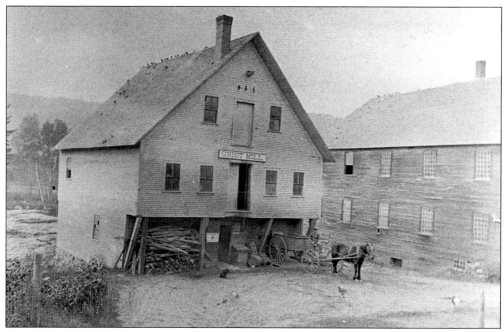

One of the grist mills that were once a common sight in the Littleton area.

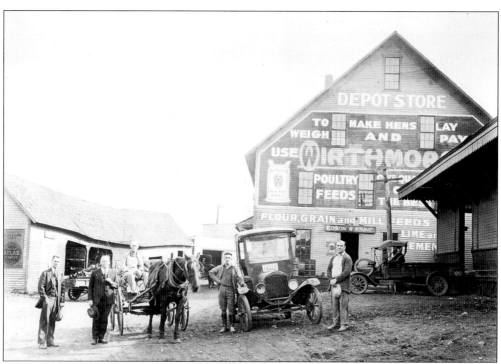

This farm supply store was established in 1836. Shown here in 1918, it is still in operation with a much expanded line of garden and pet supplies. From left to right are Fred Bowman, Harold Edson, Henry Quimby, Arthur Fitzgerald, and Shirl Lakeway. The horse remains unidentified, but the lovely vehicle is undoubtedly "Lizzie." (Albumen print, mounted.)

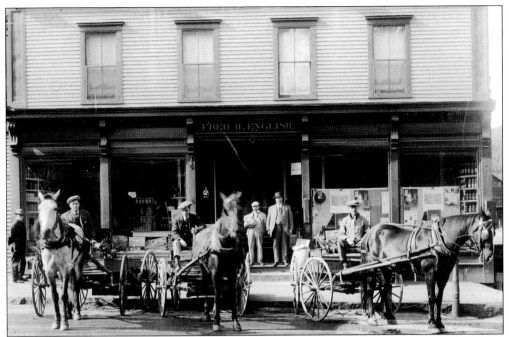

The Fred English grocery store was a fixture on Main Street for many years. Shown are, from left to right: (drivers) Bunton Beecher, unknown, and "Pat" Goode; (on the steps) "Razzie" Ranlet and Fred English. (Gelatin silver postcard.)

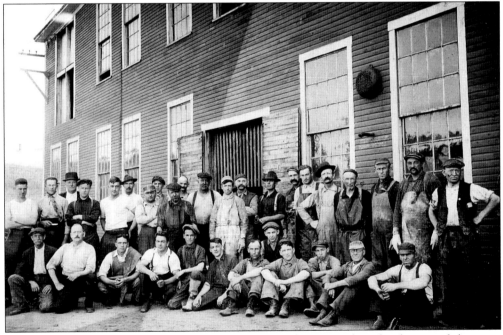

The scythe factory was one of the town's earliest industries and evidently one of the most hazardous as the plant burned to the ground on four different occasions. Note on the 1860 map on p. 4 the region that later became Apthorp is designated "Scythe Factory Village." (Gelatin silver print, mounted.)

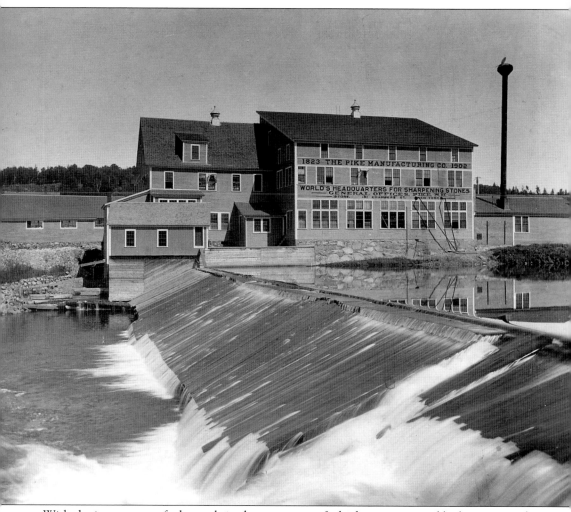

With the importance of edge tools in the area, most of which were operated by human muscle, it is not surprising that a manufacturer of abrasive (sharpening) stones established a plant here in 1901. They later merged with the Norton Abrasives Company of Worcester, Massachusetts, and are still very much in business. (Albumen print, mounted.)

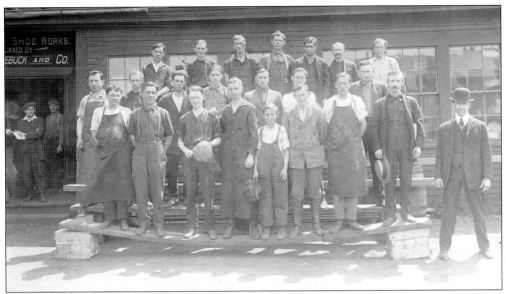

Shoe manufacturing was brought in by vote of the town in 1895 when a corporation was created for that purpose—the Littleton Shoe Company. Sears Roebuck established a plant shortly thereafter. (Albumen print, mounted.)

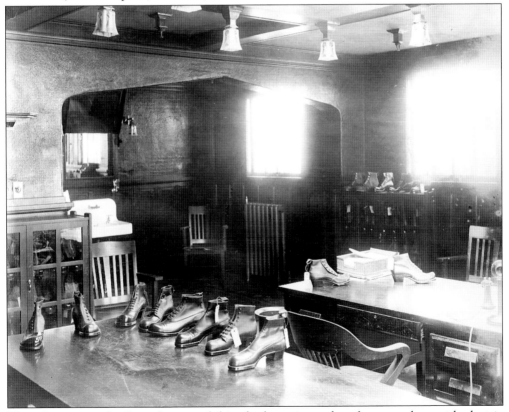

The salesroom in the Sears factory exhibits the latest in modern footwear along with electric lights, steam heat, running water, and a telephone. (Gelatin silver print.)

15

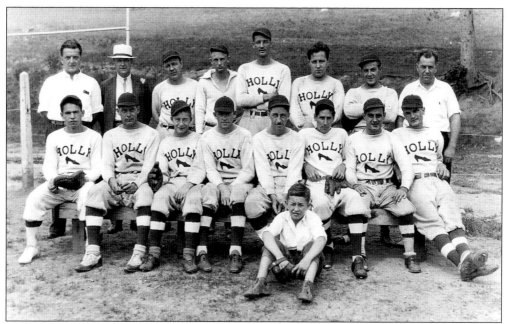

A late comer to the shoemaking scene in Littleton was the Holly Shoe Company, a Boston manufacturer of child and infant footwear. The enlightened management of this company encouraged the formation of a baseball team among the employees and equipped then with what must be one of the earliest examples of "illustrated" sweatshirts.

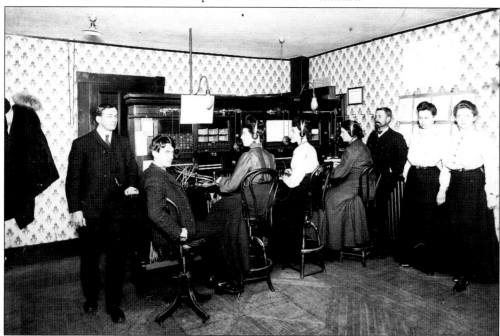

The marvellous invention of Alexander Graham Bell in 1876 came to Littleton shortly thereafter. The only person identified in this handsome group is the woman at the far right—Maude Wallace, a cashier. Later pictures in out collection show rapid growth in the size of the switchboard. (Albumen print, mounted by amateur.)

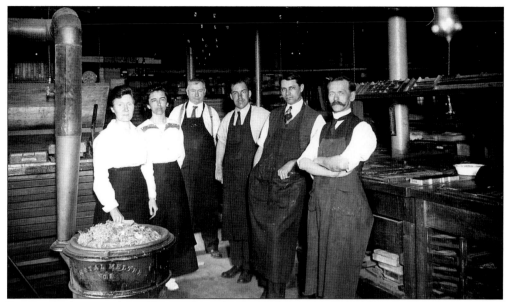

Printing at this period was "letterpress," where each letter was picked from its bin and assembled in a "composer's stick" and then locked into a form ready for the press. Newspapers and larger print shops like this one soon acquired the Linotype machine, a mechanical monster with a keyboard which selected the desired letter-mold and sent it along an arm to its proper position with its fellows. When the line was complete the machine poured molten typemetal into the mold and the line of type was ready to go into the form in one piece. A furnace for melting down the type for reuse can be seen in this photograph. (Gelatin silver print, mounted.)

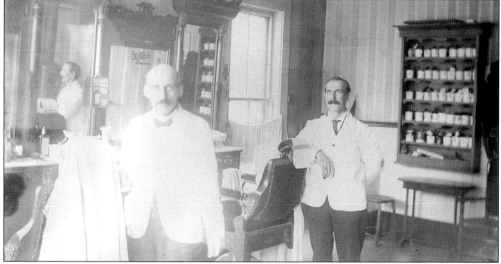

As more men entered the "white-collar" group, regular visits to the barber shop became standard practice. The shops were usually identified by the red-and-white striped pole, often rotating, which was said to be derived from the bloody bandage sign of the ancient barber-surgeon. Fortunately, the only blood shed by these practitioners of the craft was an occasional nick from the straight-edged razor. Regular customers had their own shaving mugs, as can be seen in the background. The tonsorial artists shown are George Houle and John L. Parent. (Albumen print, mounted.)

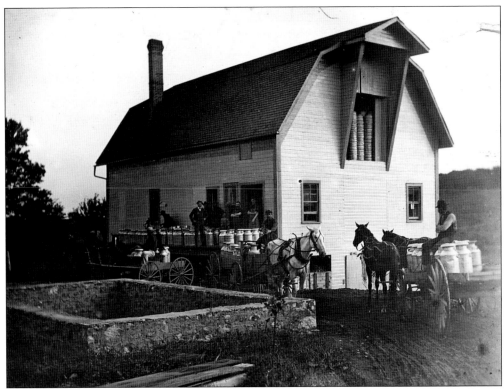

The creamery or "butter factory" was another example of the growing departure from the family farm economy that was still pretty much the standard in most rural areas at the time of this photograph. (Albumen print, unmounted.)

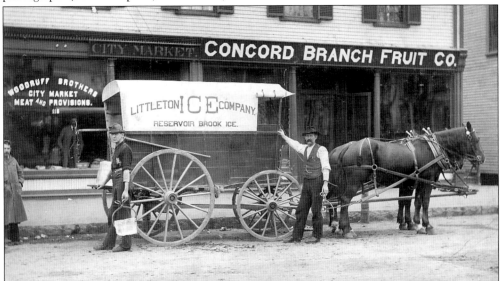

The "Ice Man Cometh," and if he didn't milk and other perishable foods were at serious risk during the dog days of summer, even in Littleton's mountain-cooled atmosphere. The familiar ice-tongs were frequently supplemented by a rubber apron-in-reverse so the heavy blocks could be carried on the back up steep flights of stairs. (Gelatin silver print.)

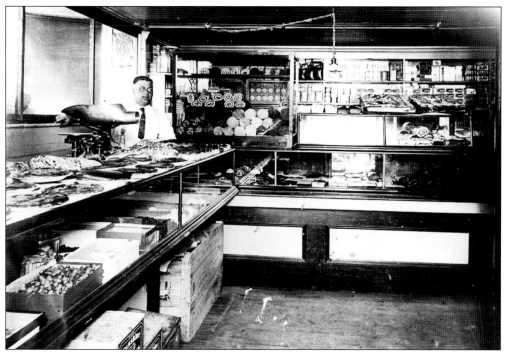

There are still those in town who remember the enchanting aroma that escaped (perhaps not unintentionally) from the Bilodeau bakery. The business started with horse-drawn delivery wagons whose wheels were replaced with runners in the winter (see p. 74); soon it grew into a thriving business based on a quality product, and the wagons were exchanged for a fleet of trucks (see below). (Gelatin silver prints.)

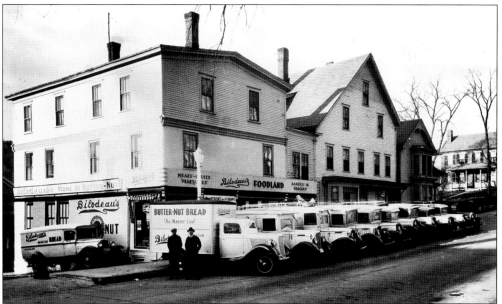

The children of Silas and Eliza Parker, six of whom are shown here, appear to have been formed in a mold labeled "successful business men." Of special interest to us here is Ira, seated in the center. It was he who began the glove business which later became Saranac Buck Gloves and Mittens, a company which developed a world market for its product. (Albumen print, cabinet mount by Cobleigh, Ltn.)

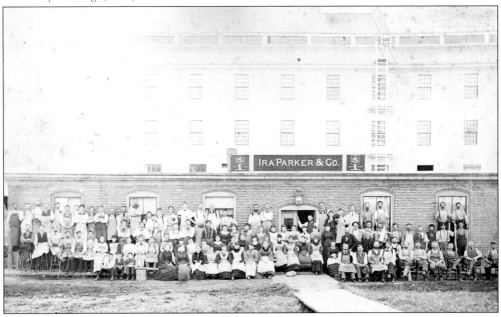

Ira Parker's glove manufactory grew rapidly as can be seen by the number of workers and the size of the plant. Improvements in tanning leather, claimed by many and probably attributable to many, greatly increased the demand for this fine product.

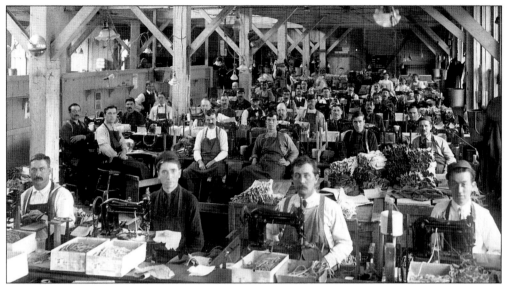

An interior view of the plant showing the manufacturing process. It is interesting that the stitchers are mostly men, though a few female workers can be seen on the right in the background. (Gelatin silver print.)

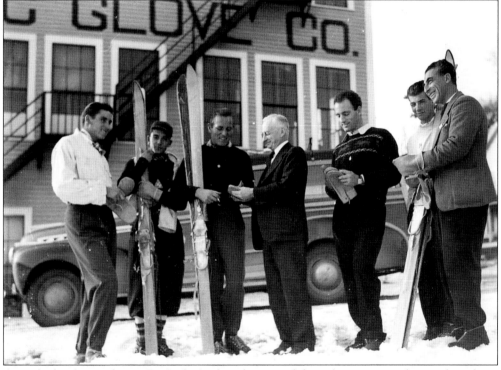

As with the shoe industry, Ira Parker's glove business did not long remain alone; other plants were quickly established, one of them by two of his brothers, but all were finally merged into the Saranac Company. President Langford is shown here presenting pairs of their famous ski mitts (often called "tow-mitts" because they helped grip the slippery, wet rope of the first ski tows) to a visiting Chilean ski team. (Gelatin silver print.)

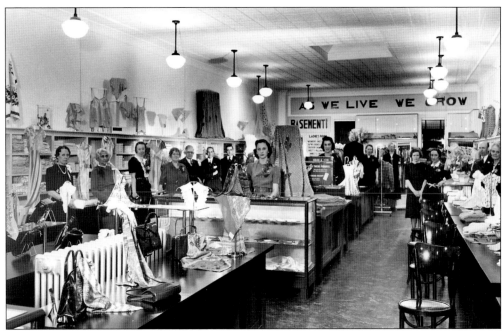

MacLeod's Department Store on Main Street offered merchandise on three floors with, in 1921, 6,750 square feet of selling space—an impressive effort for a small town. (Gelatin silver print.)

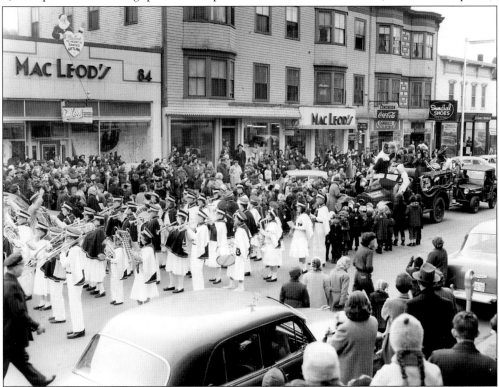

The Santa Claus parade became a major event ushering in the Christmas shopping season.. (Gelatin silver print.)

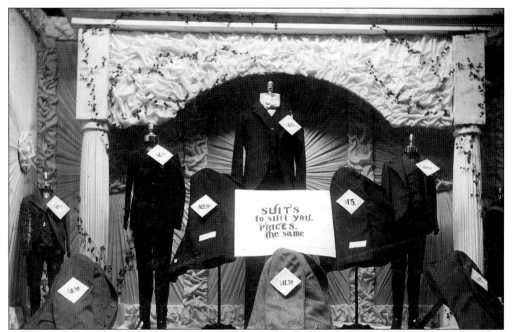

Another impressive effort was this display window in the Bellows and Baldwin store offering clothing and furnishings for men. Hardly less impressive are the price tags.

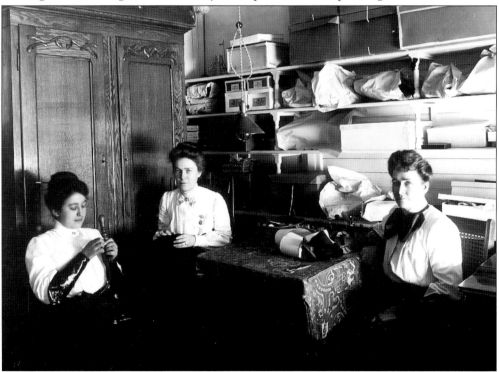

On the distaff side some workers in Mrs. Simonds' Millinery store wear leather sleeve-protectors (laundry was a bit more work in those days) as they custom-trim the elaborate headgear favored in the 1920s. (Albumen print, mounted.)

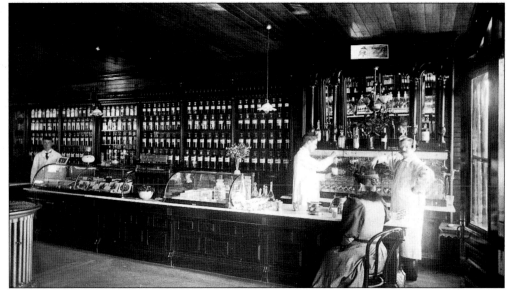

Fred Robinson (right) was justly proud of his drugstore where the modern touch of a soda fountain joined the staid ranks of bottled medicines used in compounding prescriptions. Fred Green, at the soda dispenser, later became the owner of the store. (Albumen print, mounted.)

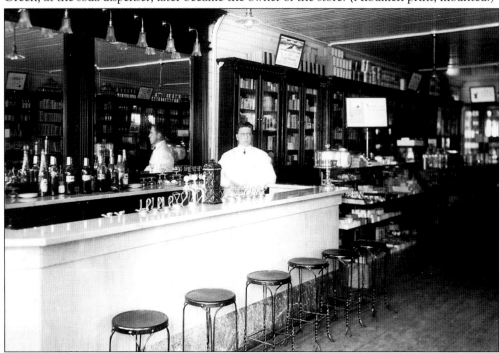

By 1912 the soda fountain was becoming a major element in drugstore operations. The bottled syrups on the shelf combined with ice cream and soda water added greatly to the "fattening of America." And don't forget "banana splits," made of a large ripe banana sliced lengthwise, three scoops of assorted ice cream, three or four fruit syrups, and nuts, all presented in a specially designed metal dish and topped with real whipped cream and a maraschino cherry (or two). (Gelatin silver print.)

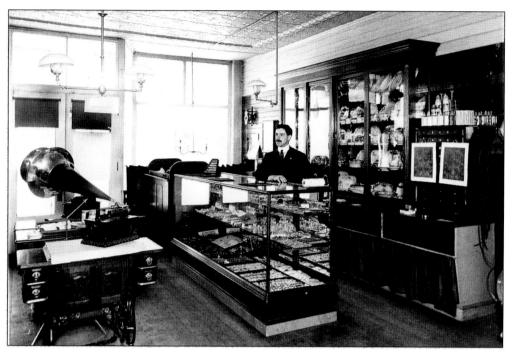

Harry F. Howe, jeweller and optician from 1887 to 1915, offered a considerable variety of merchandise in his neat store, including an Edison phonograph with cylinder records and the foot-treadle Singer sewing machine.

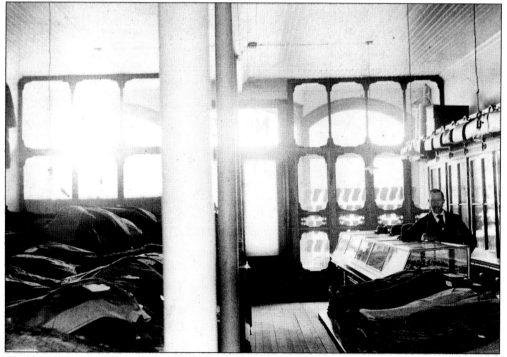

Charles M. Lane of Lane & Stocker's Clothing Store presides over his stacks of clothing in the days before display racks.

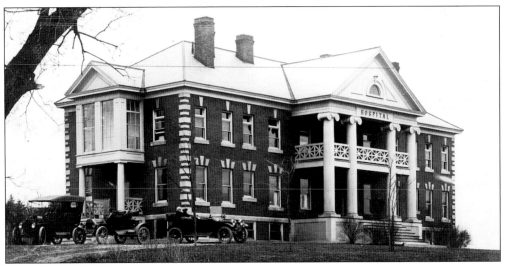

Littleton's proximity to Dartmouth Medical College (as it was called then) in Hanover a few miles downriver, as well as the not too distant University of Vermont Medical College, probably did much to account for the solid medical community the town has enjoyed over the years. The hospital had "a high efficiency X-ray apparatus and electrically operated sterilizer" and was established in 1907, largely due to the efforts of Dr. Wm. J. Beattie and generous financial supporters such as J.J. Glessner. A nursing school and home followed shortly, creating a health-care facility not equaled outside of much larger centers. (Gelatin silver postcard.)

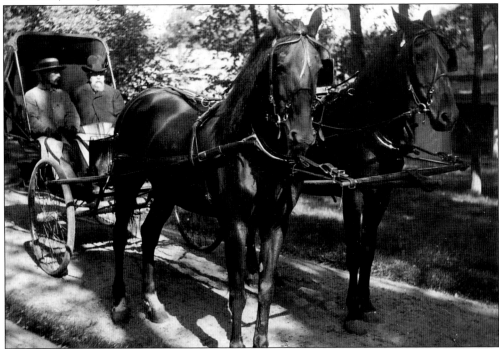

Dr. Thaddeus Sanger, a homeopathist, lived and practiced in the town for forty-five years. With his fine team of Lady and Dandy (we're not sure which is which), he made many a house call when such were the fashion, bringing, it is said, "cheer and confidence into the sickroom." (Albumen print.)

A *rara avis* indeed for her time was Dr. Barbara Beattie, daughter of the well-loved Dr. Wm. J. Beattie. Not only was she a pioneer by being a woman doctor but as a pediatrician she was a leader in the new trend toward medical specialization. (Gelatin silver print.)

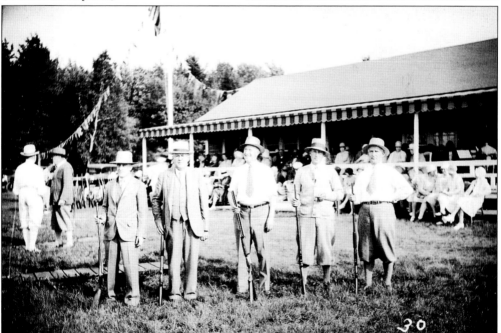

The medical fraternity in a rare relaxed moment. From left to right are John Mathes (pharmacist), Drs. Page and Tewksbury, Roland Peabody (of Cannon Mountain Aerial Tramway fame), and Dr. Bates. (Gelatin silver print, mounted.)

Dr. Willard A. Bates in his World War I uniform. Dr. George McGregor.

No attempt at completeness has been made here in this random selection of Littleton physicians. The ones portrayed are simply those whose photographs appeared in the subject collection. (All are Gelatin silver prints.)

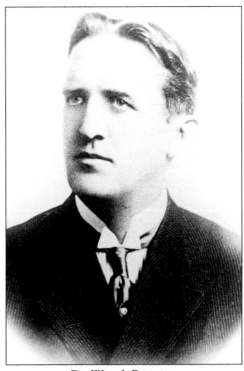

Dr. John M. Page. Dr. Wm. J. Beattie.

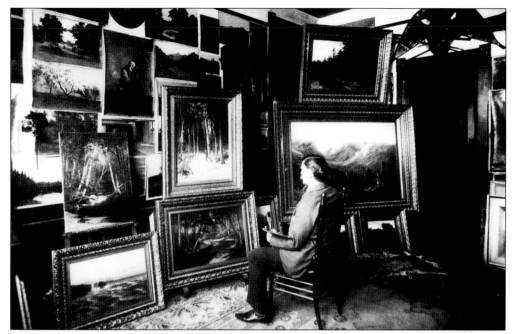

Artists as well as photographers have long been attracted to this mountain region because of the magnificent scenery. One of the best known was Edward Hill, shown here in his Littleton studio. Like so many of his profession, fame came to him only after his death. (Copy print; original unknown.)

Daniel J. Strain was another local artist of note, known mostly for his portraits and heads of children. Several of the former still hang in the State House in Concord. (Copy print from the *Granite State Monthy*, 1894; collection of Linda McShane.)

Photographers seem not to have been prone to photograph themselves or to have their portraits made so we have few records of their appearance. An exception is this photograph of Elec F. Hall, one of the best in his profession to have worked here, before moving on to Buffalo, New York. As well as being an accomplished photographer, Hall was a musician (see p. 70). (Gelatin silver art print, possibly by Hall himself.)

Myra Eaton (shown) and her sister Julia were talented artist-photographers who had a studio-shop at the corner of Main and Jackson Streets in the early 1900s. They specialized in portraits and Myra hand-decorated china. (Gelatin silver art print, probably by Julia Eaton.)

Needless to say, a town with the lively business and political interests of Littleton required the talents of the legal profession. Judges James W. Remick and Harry L. Heald, two of the many practitioners in this field who gave generously of their time and ability to benefit the community, are pictured here in a relaxed outing at Kittery Point, Maine, in 1940. (Gelatin silver print.)

Judge Harry Bingham, although not a native son, came to Littleton when he passed the bar in 1846 and spent the rest of his long, active life here until he died in 1900. He served the community and the state in countless ways and with unremitting devotion.

Daniel C. Remich, a practicing attorney, was another adopted son of the community whose ability and drive conferred permanent benefits on his chosen town. After his marriage to Benjamin Kilburn's daughter Elizabeth he joined his father-in-law in the stereo card business.

Two

Events and Visitors,
Fires and Floods

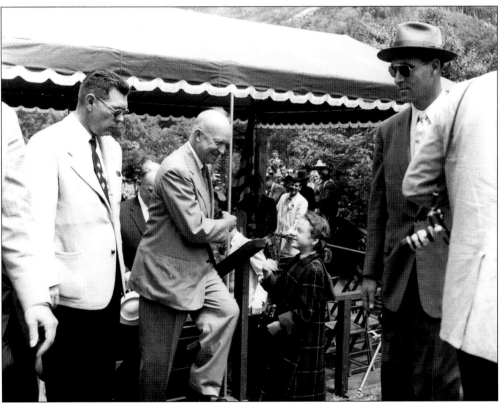

Over the years Littleton has entertained its share of distinguished visitors, partly because it was a population and business center and partly because of its scenic attractions and the grand hotels scattered throughout the area. Here, President Dwight D. Eisenhower converses with a young admirer at the dedication of the Littleton section of I-93—a highway construction program he inaugurated.

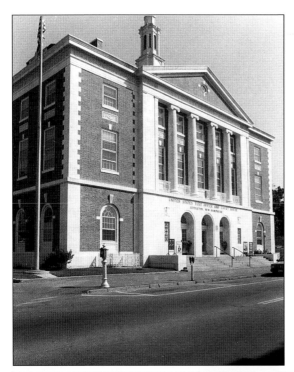

In 1935 Littleton saw the completion and dedication of its grand new Federal Building. There is a story that the building erected here was designed and intended for a much larger town but through political manipulation Littleton fell heir to this handsome structure.

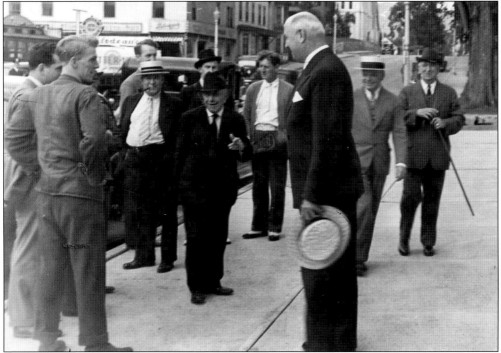

Postmaster-General "Big Jim" Farley was of course on hand for the dedication and talks here with some of the local citizenry. Also on hand were Dr.-to-be Richard Hill (on the left), "Razzie" Ranlett (in the center, gesturing), and Burt Richardson (at the far right, with the walking stick). (Gelatin silver print.)

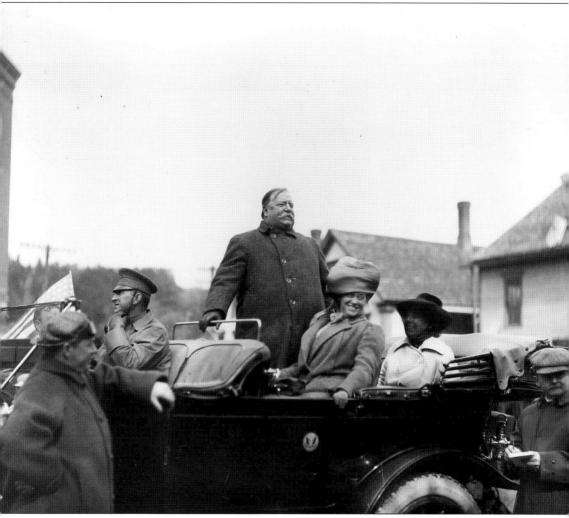

Moving back a few years to 1912 President William Howard Taft addresses the citizens of neighboring Lisbon in the town square. It is a wonderful photograph, with every figure contributing to the whole as well as having its own story. (Albumen print, mounted.)

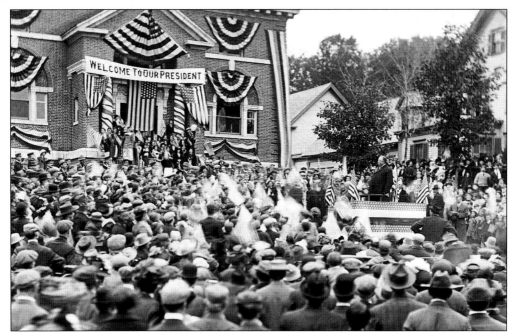

President Taft then continued on to Littleton where he spoke to a huge gathering in front of the Littleton Public Library. What an effort it must have been to make open air speeches to crowds this size with no artificial aid. (Gelatin silver postcard.)

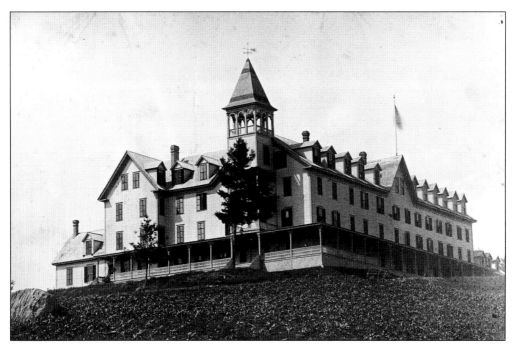

The Oak Hill House was a landmark on the heights above Littleton Village from the time it was built until, like so many of its ilk, it was destroyed by fire in 1895. Its six-horse coach was featured in many of the Bethlehem coaching parades. (Albumen print, mounted.)

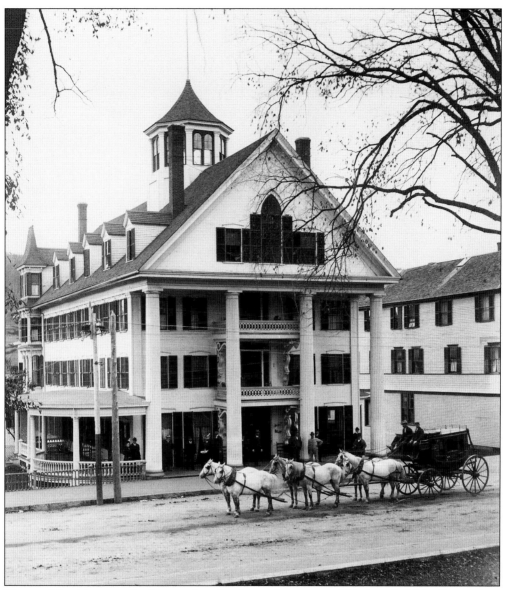

Thayers Hotel has stood, almost miraculously, at the center of Littleton's Main Street since 1850 and may be one of the oldest continuously operating hostelries in America. (Gelatin silver print.)

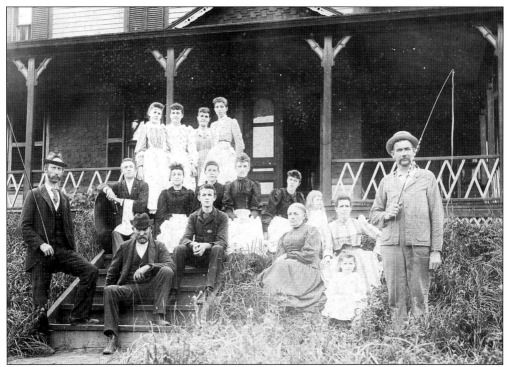

Though perhaps not on the "grand" scale, the Chiswick Inn (shown in the days before lawn mowers) was a comfortable inn with a homey touch. The two gentlemen with the fishing poles practically guarantee trout for breakfast.

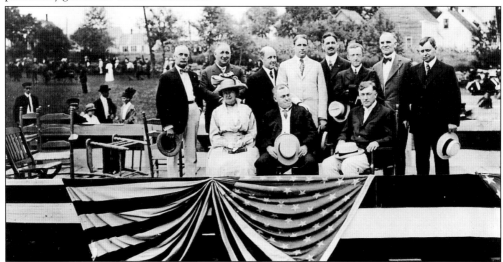

Not so much a visiting dignitary as a "return of the native," Eleanor Hodgman Porter, renowned author, is seen here during Old Home Week in 1916 with local and state officials. She was the creator of the Pollyanna books and has the distinction of having added a new word to the American language. Shown here are, from left to right: (front) E.H. Porter, Judge Wm. Sawyer, and Governor Rolland H. Spaulding; (back) Geo. H. Tilton, Albert J. Richardson, Reverend Wm. A. Bacon, Robert Jackson, Harry S. Baldwin, Harry L. Heald, Harry Bingham, and Fred Campbell. (Copy print; original unknown.)

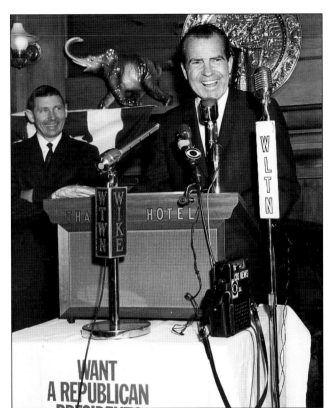

Richard M. Nixon appears to have pleased himself as well as the audience gathered at Thayers Hotel during his presidential campaign. Ray Carbonneau joins in the merriment. (Gelatin silver print by Lawrence Presby, Ltn.)

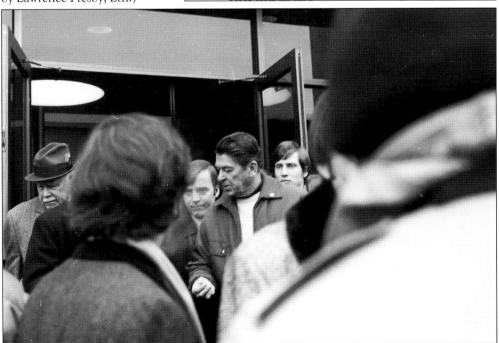

President (or candidate?) Regan on the other hand appears to be making a serious point. Where are we stopping for lunch? (Gelatin silver print.)

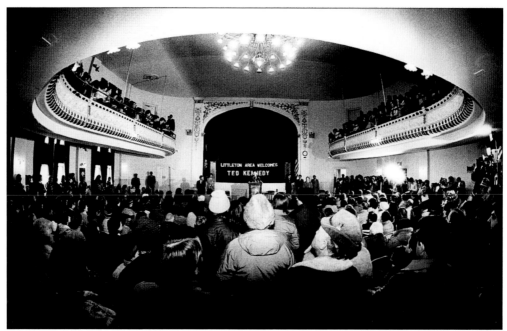

A capacity crowd greets Ted Kennedy in Littleton's handsome Opera House. (Gelatin silver print by Andrew G. Wainwright, Ltn.)

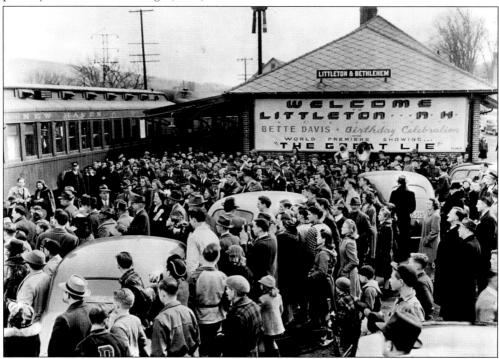

Possibly the greatest social event in Littleton's history occurred in April 1941 when movie star Bette Davis came here to celebrate her birthday and be present at the premiere showing of her latest film *The Great Lie*. Eager crowds await the star's arrival at the train station. (Gelatin silver print by Warner Brothers photographer.)

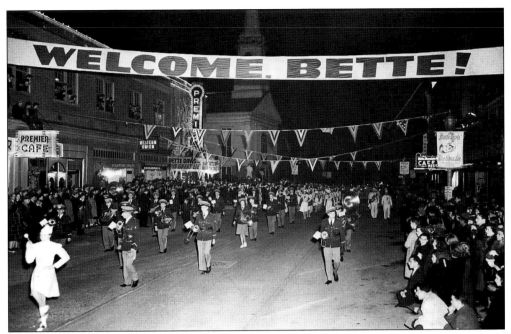

The streets were thronged for the torchlight parade down Main Street complete with a band and drum majorette, state police, and Boy Scouts. Second story window seats were at a premium.

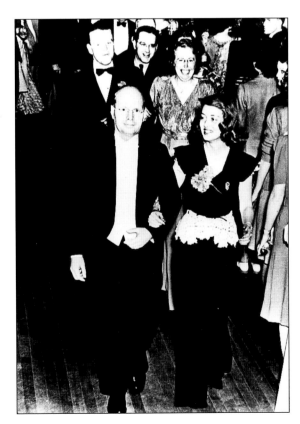

In the Opera House Bette leads off the Grand March on the arm of Governor Robert O. Blood. (Copy print from Warner Bros. photograph.)

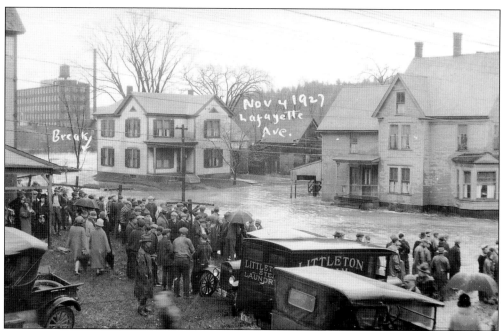

"Into each life a little rain must fall," but a great deal fell on Littleton in November 1927 when the flooded rivers swept through the streets. (Gelatin silver postcard.)

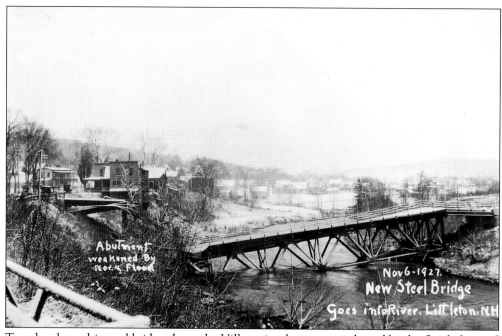

Two days later this steel bridge above the Village, its abutment weakened by the flood, dropped into the river. (Gelatin silver postcard.)

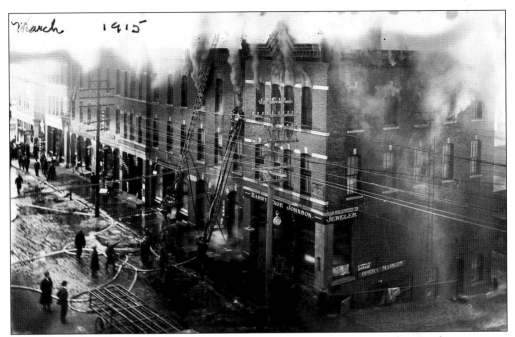

All communities experience their disastrous fires. They are almost expected in wooden structures like the grand summer hotels, most of which have been lost in this way. Fires such as this March 1915 blaze in the Opera Block somehow seem worse, however, perhaps because the great brick buildings look so impervious. (Gelatin silver postcard.)

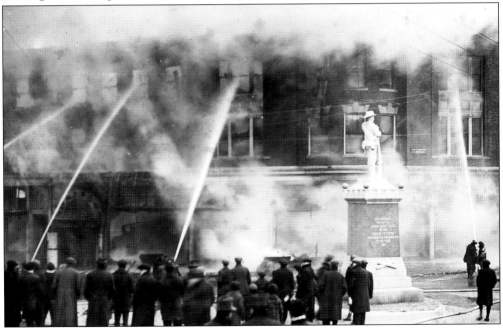

Just two years later a similar conflagration swept the Salomon Block. The Soldiers Monument stood in front of the Town Building at this time but has since been moved. It is said the movers (Ken Curran was the contractor) took him on a little tour about town before settling him down at the entrance to the Glenwood Cemetery. (Gelatin silver postcard.)

When the ice breaks up on the rivers in the spring it is not unusual for great blocks to be pushed up on the low-lying banks. This accumulation just above Apthorp in 1911, however, is definitely out of the ordinary. (Albumen print, mounted, by Mr. Hayden.)

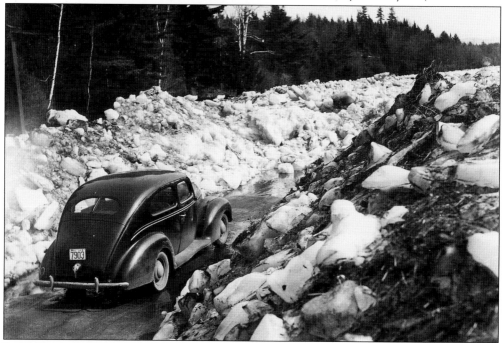

In 1945 ice piled up again on the Old Whitefield Road high enough to conceal a car. The New Hampshire license plate is 7903. Can anyone identify the owner?

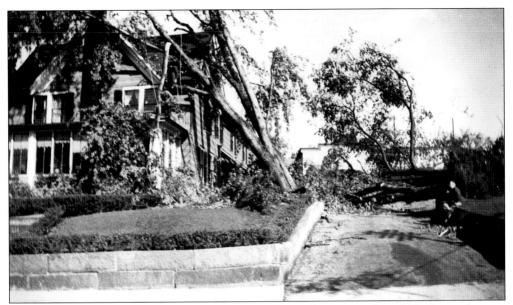

The worst hurricane ever to strike New England occurred in September 1938. As can be seen in this snapshot, huge trees were uprooted and tossed about damaging houses, blocking roads, bringing down power and phone lines, and generally devastating the area. It was many months before the worst of the damage was repaired.

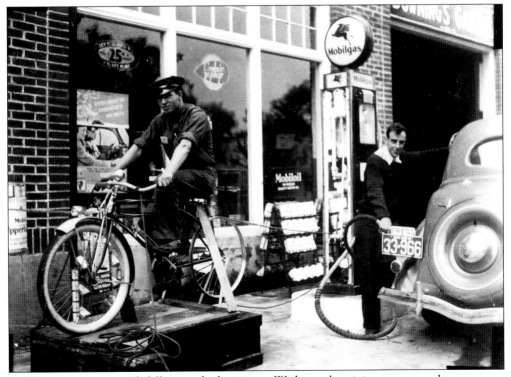

Yankee ingenuity at work following the hurricane. Without electricity to operate the gas pump, bicycle-power is substituted. (Gelatin silver print.)

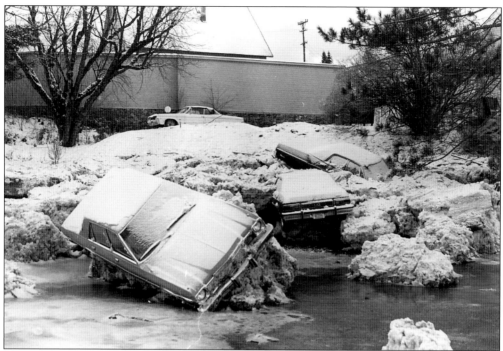

In 1981, the Ammonoosuc, just to show it hadn't really been tamed, went on another rampage, pushing ice up onto the low-lying banks and tossing cars and buildings around like toys. (Gelatin silver prints.)

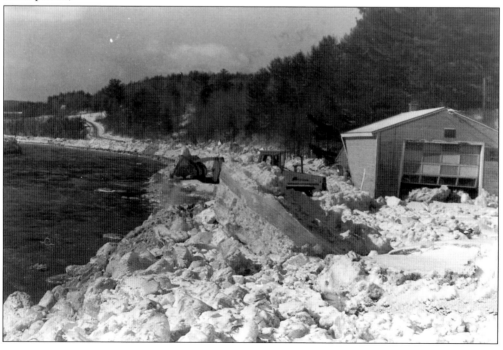

Three

Transports of Delight

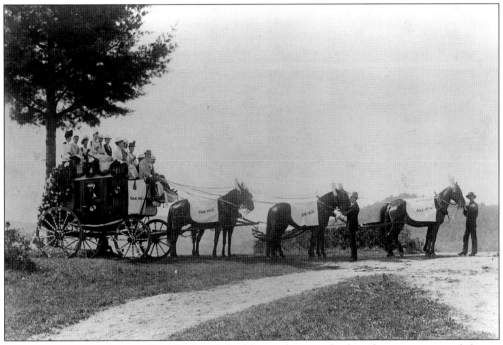

In the pre-automobile era all of the hotels had horse-drawn vehicles of various sizes and shapes from the six-horse coach down to the "one-hoss shay." The coaches met and delivered guests at the railway station, and during their stay (often a month or more), visitors were shuttled around by the same coaches to various points of interest in the vicinity. The rivalry between these handsome equipages was expressed good-naturedly in the Bethlehem coaching parade or Gala Day, when coaches for miles around, filled with handsomely dressed ladies and gentlemen, assembled in the town and paced majestically along the streets. In the above photograph, the coach from Littleton's Oak Hill House readies for the parade. (Albumen print, mounted; Hall Studio, Ltn.)

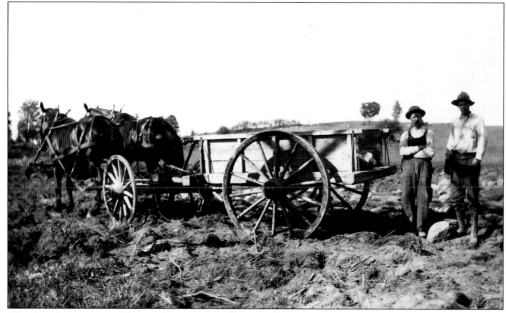

Charles Carpenter and Napoleon Rainville are shown here at the Eastman Farm in North Littleton clearing the field of one of New Hampshire's most widespread crops—rocks. Sturdy wagons like this one were essential equipment for the farmer, and they were in constant use moving materials to, from, and about the farm. Note the large wheels, which made travel over the rough terrain easier.

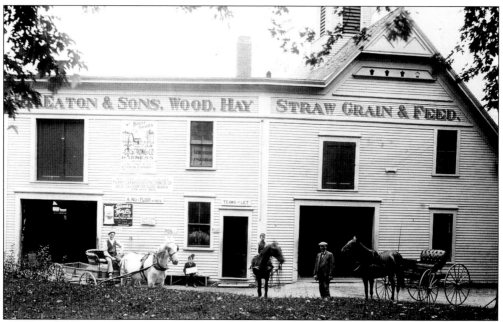

What might be termed the "horse culture" is typified in this pleasant scene. Howard Eaton sits in the wagon behind the white horse, his son Steve is astride the horse in the center, and Hosea B. Mann stands to the right. (Gelatin silver postcard.)

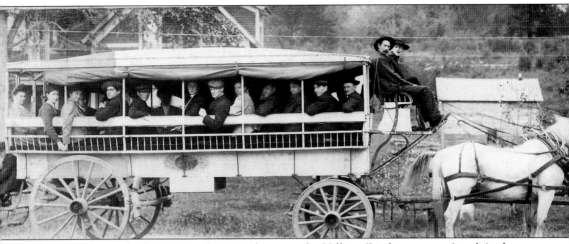

This marvelous vehicle ran a regular route between the Village (Littleton center) and Apthorp at the east end, where many mills and factories were located. Hand-written information on the back states, "On the way to the old Shoe Shop near Apthorp Bridge, early 1900s." (Albumen print, mounted.)

This Ticket⟶ $1.50

 Entitles the bearer to one month's
 ride from the Village to Apthorp,
❀ THREE TRIPS A DAY, ❀
 on
 H. S. DREW'S BARGE

From _____ to _____

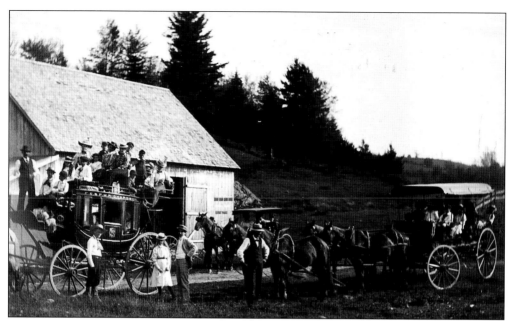

This happy group is headed for a Unitarian Sunday School picnic at nearby Partridge Lake, some in the Partridge Lake stage, some in the surrey drawn by four horses. The stagecoach was owned and operated by F.E. and F.M. Richardson.

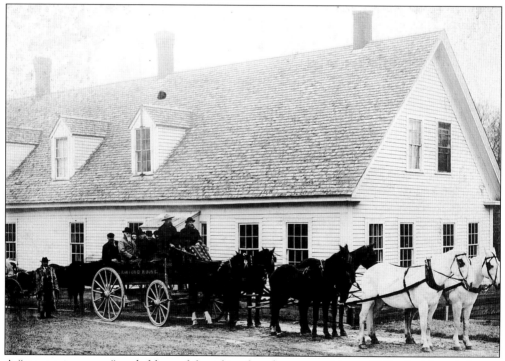

A "mountain wagon" probably used for taking hotel guests up Mount Willard, although burros were more commonly used and better suited to the terrain. Presumably this and similar vehicles were also used on the Carriage Road up Mount Washington and Mount Agassiz. (Albumen print, mounted.)

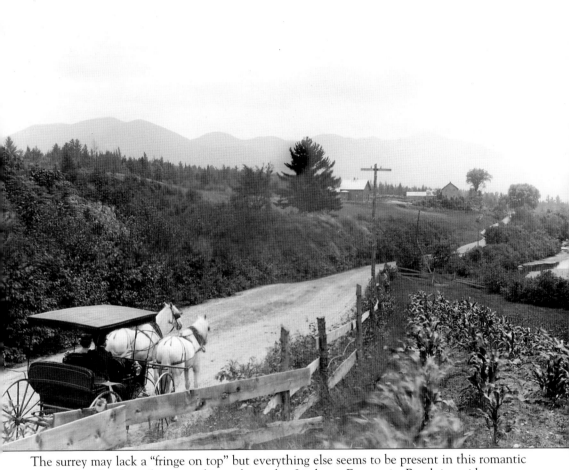

The surrey may lack a "fringe on top" but everything else seems to be present in this romantic scene of a Sunday afternoon drive along the Littleton-Franconia Road in mid-summer. Hopefully, the handsome white horses were as docile as they looked and could be depended on to maintain their leisurely pace if the driver was momentarily distracted. (Albumen print, mounted.)

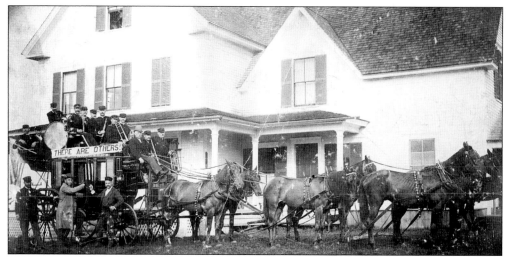

The Littleton Band atop a six-horse stagecoach pauses in front of the home of Mrs. Ella Nourse Carter. The year is 1895. (Albumen print, mounted.)

The era of the horse in Littleton, as elsewhere, began to disappear with the coming of the railroads and the development of the internal combustion engine, but the attachment held strong for many. Indeed, Littleton has one of the few horse cemeteries which may lay claim to having caused the deviation of the proposed course of an interstate highway. The above photograph is of businessman James C. MacLeod (MacLeod's Department Store), a member of the Governor's Council and one of the many who gave up their "friends" reluctantly.

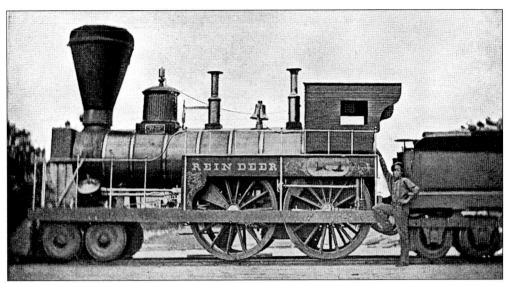

In 1853 the "iron horse" reached Littleton, having worked its way up from Boston on much the same course taken by the early settlers. Faced with the tremendous task of cutting through Crawford Notch to get to Portland, the railway paused at Littleton, which became for some time the eastern terminus of the White Mountain Railroad. The above photograph is of the first locomotive to run into Littleton. (Halftone print, copied by A.A. Pennock, Ltn.)

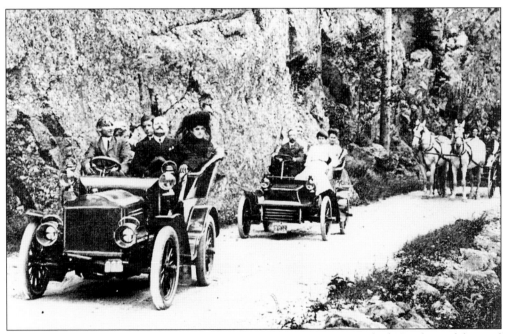

By the turn of the century "horseless carriages," as seen here in Crawford Notch, vied for road room with the genuine article. Horses, hardly surprisingly, did not always take kindly to the intruders but the pair shown here seem to be taking things in stride. Standard equipment for early automobilists included goggles for the operator and heavy veils to protect milady's skin against the 15 mph wind and dust. One senses this picture may have been posed with parked cars. (Halftone print.)

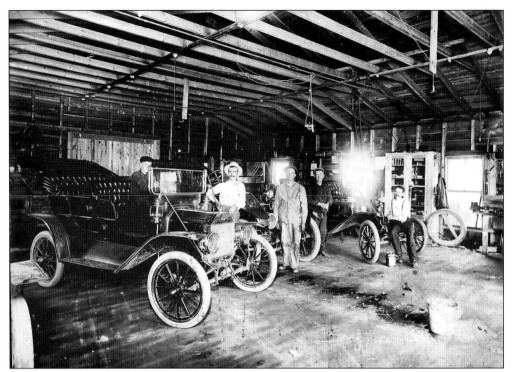

Then, as now, cars needed repairs, especially tires which, after the pneumatic ones were introduced, could be expected to go flat every few miles. Early garages were established in empty barns and factories, often near livery stables. (Albumen print, mounted.)

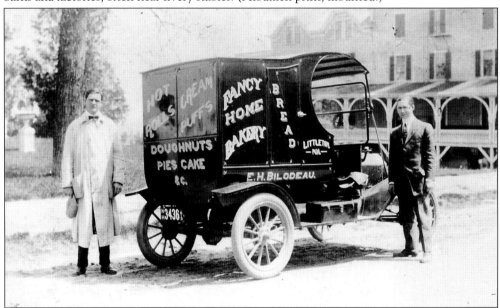

Pleasure vehicles were quickly followed by commercial ones like this, proudly displayed by E.H. Bilodeau and son in 1913. The tool box on the running board was essential and much-used equipment. The driver is attired in the accepted operators' garb of dustcoat and cap (in hand). (Gelatin silver print.)

54

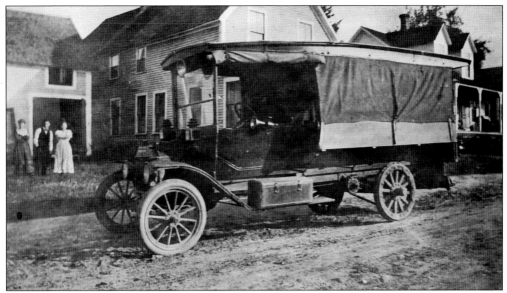

This may be a delivery truck or possibly a passenger "jitney." Note the tool box, chain drive, and solid rear tires.

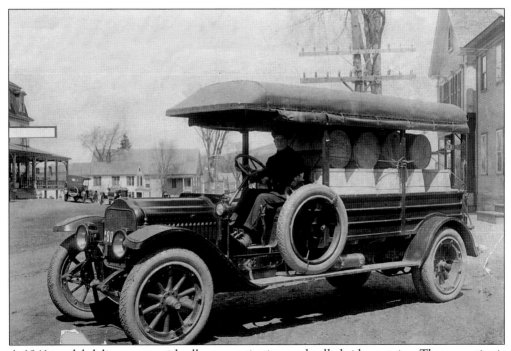

A 1941 model delivery van with all pneumatic tires and rolled side-curtains. The spare tire is just that, not a wheel. Flats had to be changed on the road and tube-patching equipment was essential. Inflating tires like these with a hand pump did not make for obese drivers.

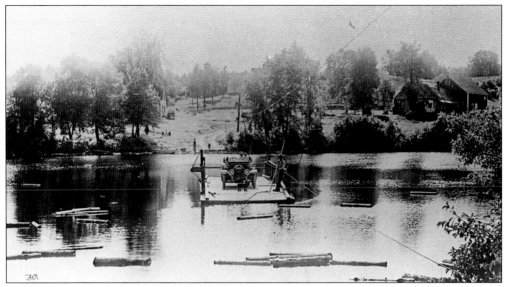

Dalton, just above Littleton, lies across the Connecticut River from Lunenburg, Vermont, and as the river is fairly broad here, a ferry is more affordable, if less useful, than a bridge. It is not known if the dog was a passenger in the car or regularly oversaw the operation of the ferry.

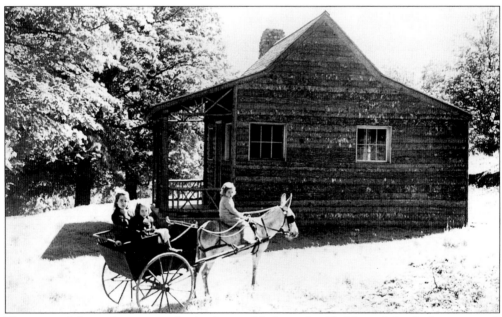

The automobile was here to stay for the foreseeable future but Neddie and the donkey-cart spell happiness for the Lincoln Adams children at the Hilltop Schoolhouse: Beth and Caroline are in the cart, with Briggs aboard Neddie.

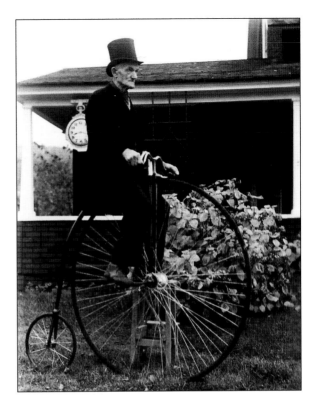

High-wheeled bicycles were perhaps never intended to be practical, but if so, the inventor missed. Getting on and off was enough to discourage anyone but a circus performer or Mr. Henry Sabine, who took time off from watch and clock repair to show his skill. (Gelatin silver print.)

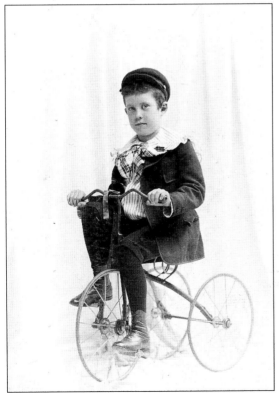

The young man on a three-wheeler, Harold Young, is quite obviously posed for a studio portrait, but trikes were very popular among the small fry who had not graduated to a real bicycle. (Albumen print, mounted; M.D. Cobleigh, Ltn.)

57

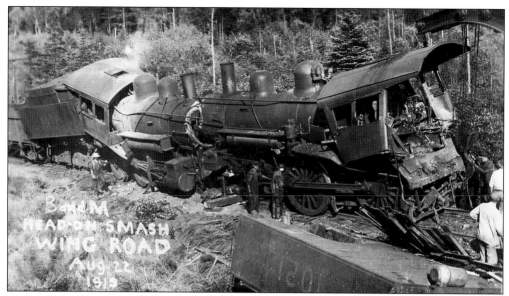

Railroad wrecks were relatively uncommon considering the amount of traffic on the tracks before trucks began moving large portions of freight and everyone owned a car or two. However, when errors did occur they often resulted in spectacular collisions, such as this one near the Littleton-Bethlehem line.

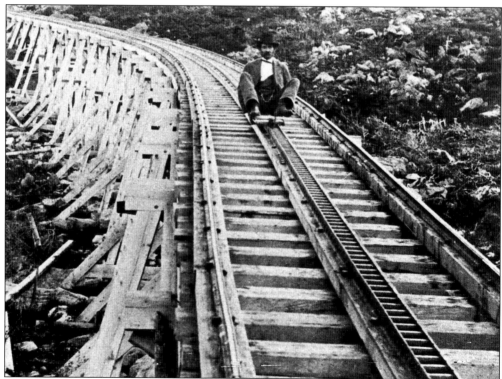

The slide-board or "devil's shingle" used by workers on the Cog Railway (see next page) would not be everyone's idea of safe, comfortable transportation but it was a speedy way to get down the mountain. (Copy from an albumen print by Franklin G. Weller, Ltn.)

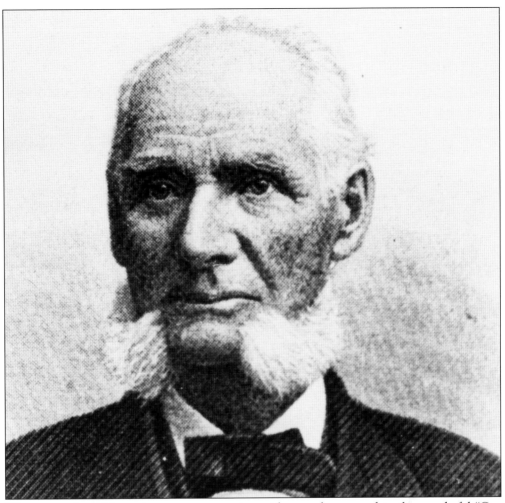

We cannot close this section on transportation without at least a nod to the wonderful "Cog Railway" on Mount Washington. It was invented, the first of its kind in the world though others followed it, by Sylvester Marsh, a New Hampshire native and at that time a resident of Littleton. As the railway terminated in Littleton at that time, all the materials except timbers cut on site had to be hauled by draft animals 25 miles over rough terrain to the base at Marshfield. Interestingly, Marsh was not an engineer but a successful businessman recently retired from the meat-packing industry in Chicago. Having decided on the feasibility of his plan he applied to the New Hampshire legislature for a charter which was granted in 1858 despite the comment of one legislative wit, "Let him build a railway to the moon if he wants to." Marsh then purchased 17,000 acres of land more or less following the Old Crawford Path to the summit of the mountain. In spite of delays caused by the Civil War, the first locomotive, Hero (much better known as Old Peppersass), made its trial run in 1866, and on August 27, 1869, the first president to visit Mount Washington, U.S. Grant, rode the train to the summit.

Peppersass performed valiantly until taken out of service in 1878 to be replaced by a more efficient horizontal boiler-type engine. It was then sent off to two world expositions, but mysteriously disappeared from view in 1904. Due largely to the efforts of a local minister, Reverend Guy Roberts, it was finally located in Baltimore and sent home. After an overhaul in Concord it came back to the mountain for a final celebration run before being put on permanent exhibit.

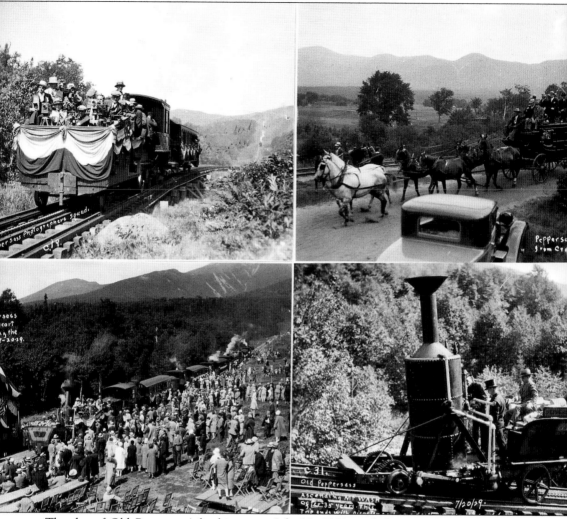

The day of Old Peppersass' final run was July 20, 1929, and throngs of invited guests and sightseers gathered expectantly, never guessing the day would end in disaster.

Upper Left: Sightseers and photographers ride an escort train with a passenger car in front and an open car behind.

Upper Right: Guests from the Crawford House arrive in the hotel coach.

Lower Left: Only a small portion of those wanting to board could be accommodated; the rest had to stand and watch as the escort, followed by Old Peppersass started up the mountain.

Lower Right: Engineer "Jack" Frost and Fireman Bill Newsham were the only authorized riders on the engine and tender but three overzealous photographers hitched a ride in the tender. The train reached a point just above the famed Jacob's Ladder when the engineer decided it was time to start the descent so as not to delay the faster-moving passenger train. Shortly after starting down the cog jumped out of its track and the train went out of control. On orders from the engineer, four of the men jumped and survived with varying degrees of injury. The fifth, B&M photographer Lawrence Rossiter, stayed aboard and was killed when the train veered off the track on the trestle at Jacob's Ladder.

Four

Entertainment and Amusement

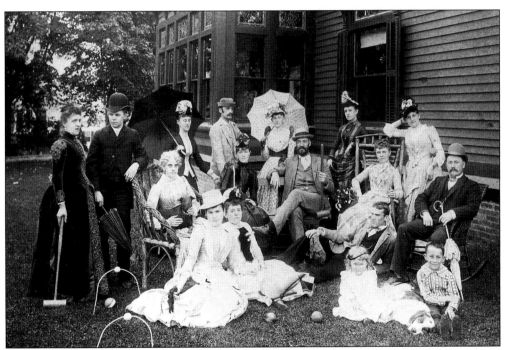

In earlier, simpler times, once the era of incessant dawn to darkness toil began to pass, people entertained themselves to a large degree. Husking bees, barn dances, and occasional visits to and from neighbors had to suffice in the early communities. As wealth and leisure time accumulated other amusements were sought. Croquet was a game to be enjoyed by genteel ladies, gentlemen in bowler hats, and children, although in the case of the latter the game was apt to be a little more hectic. This lawn party took place in the summer of 1887 outside the then new Ira Parker "mansion." Mr. Parker is seated in the center holding a croquet mallet; directly behind him, with the parasol, is Elizabeth Kilburn Jackson Remich, the daughter of Benjamin West Kilburn. (Albumen print, mounted; Hall Studio, Ltn.)

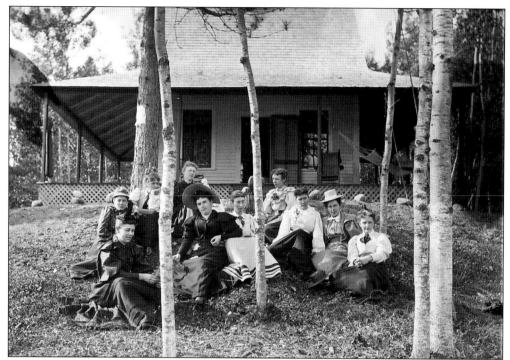

Picnics were of course popular, considering the beauty of the countryside. This cheerful group at the Fred English cottage on Partridge Lake appears to be ladies only; perhaps the men are boating, fishing, or playing scrub. (Albumen print, mounted.)

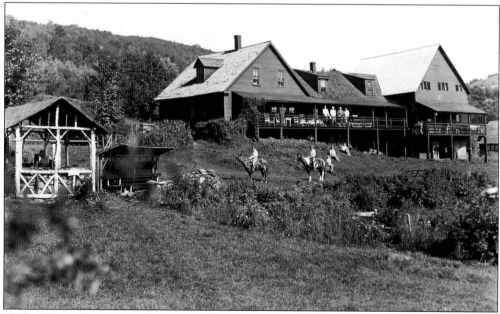

Skyline Farm on Mann's Hill, the summer residence of Reverend John E. Johnson, was donated by him to the community as part of the Community House project sponsored by Harry Heald. Its magnificent views of the mountains and miles of hiking and riding trails provided many with hours of healthful outdoor enjoyment. (Gelatin silver print.)

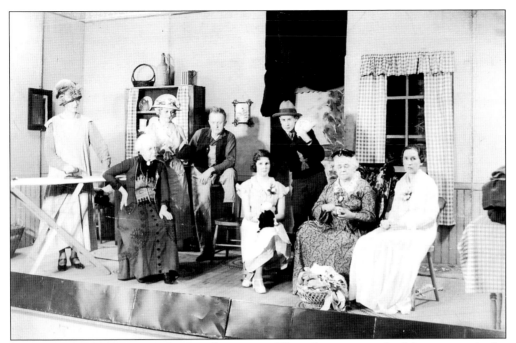

Amateur theatricals were another popular pastime. The rather surprisingly elaborate stage in the Opera House provided the players with near-professional surroundings, which greatly enhanced the performances. (Gelatin silver print.)

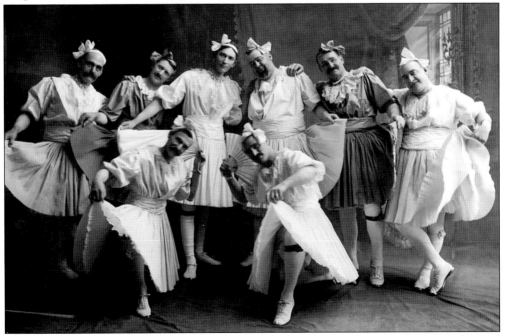

The stage performances did not always run to heavy drama. The "Pony Ballet" includes Fred and Frank Richardson, Fred English, Carter Nutting, Dr. Young, Hiram Gardner, Henry Peabody, and Harry Page Johnson, but for modesty's sake no attempt will be made to identify them further. (Gelatin silver print, mounted.)

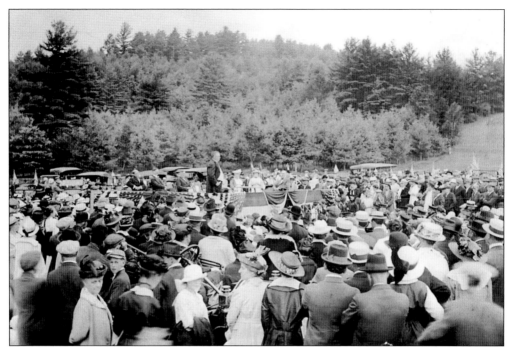

Old Home Day (or Week) was always a major event but this one in August 1916 which brought Eleanor Hodgman Porter back to her native town (see p. 38) seems to be especially crowded. (Gelatin silver print.)

The fiftieth anniversary of the Blue and Grey, July 1–4, 1913, at Gettysburg. From left to right are Warren W. Lovejoy, William Rives, Spencer A. Vaudecar, Thomas Golden, Ellery Currier, B. Olmstead, George Cleasby, William W. Weller, Curtis Bedell, Frank Burnham, and Russ Miller. (Gelatin silver print, mounted.)

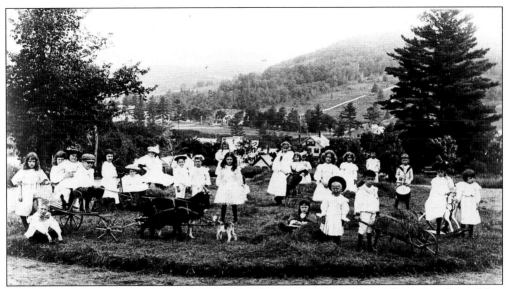

Margaret Merrill (center, with long dark hair) entertains at a party for a number of her friends. The occasion is not known; it may be an "un-birthday" party, as Margaret was born in December. Driving the goat-cart is Arthur "Peb" Strain, grandfather of the present owner of the photograph. (Copy from an albumen print, collection of Linda McShane.)

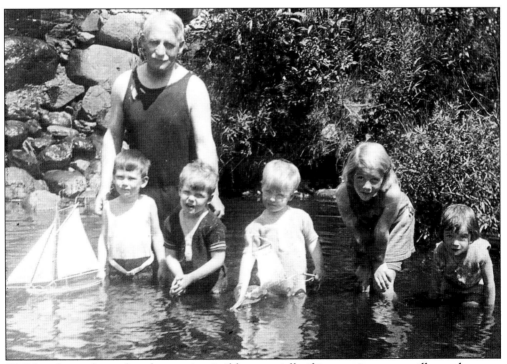

Children have always found water irresistible, especially if it contains a toy sailboat; these are the grandchildren of William Brown Dickson. (Gelatin silver print.)

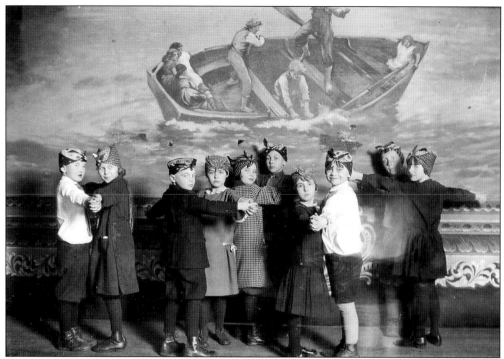

A children's group known as the "Rainbow Minstrels" entertains at the Opera House in 1925. From left to right are Nichol D. Cragie, Effie Simons Willey, Elliot Mason, Mary Childs Miner, Louise Nute Peabody, Mary Sweeney, John Semanik, Lawrence Colby, and Marion Morrison Davis. (Gelatin silver print.)

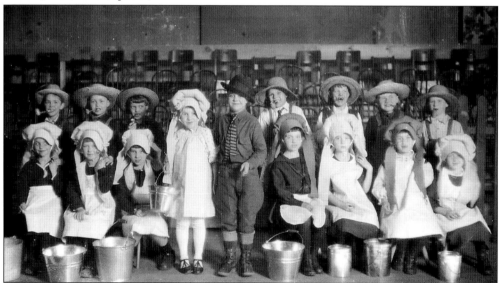

Another group of the "Minstrels" in a different performance, certainly bucolic in nature. Only a few have been identified: (center) the stars Jennie Ingalls and John Allen; (front row, fourth from the right) Beverly Maxwell; (back row, fourth from the right) Robert C. Hill, who later became the U.S. ambassador to Costa Rica, El Salvador, Mexico, Spain, and Argentina, in that order.

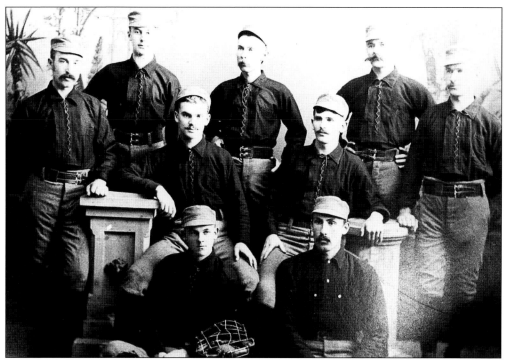

Baseball was the most popular summer sport long before the days of professional teams and million dollar salaries. In addition to school teams, there were town teams, company teams, and fun teams. The members of the Littleton Baseball Club of 1884 were: (on floor) Bingham, SS; and McCarthy, 2B; (seated) Hodgman, C; and Giswold, P; (standing) Dimmock, 3B; Parker, LF; Collins, CF; Priest, RF; and Chase, 1B. The formal studio backdrop and artistic arrangement are typical of this photographer's work. (Albumen print, mounted; E.F. Hall, Ltn.)

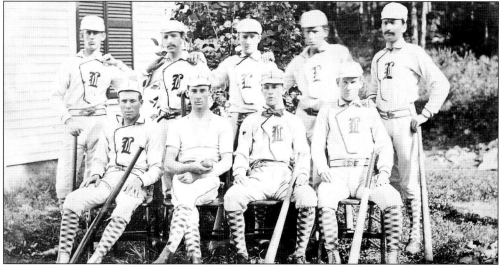

The club of 1876 is nattily attired in monogrammed shirts and fancy socks. They are, from left to right: (seated) Shepard, 2B; Tuttle, P; Van Houten, C; and Chase, 3B; (standing) Cochrane, 1B; George, CF; Johnson, RF; Byron, LF; and Parker, SS. (Albumen print, mounted; B.W. Kilburn, Ltn.)

The "Littleton Old-Timers" are: (front row) Geo. H. Tilton Sr., Geo. H Tilton Jr. (mascot), Henry Prince, an unnamed ball chaser, and Edward Young; (back row) Arthur Buffington, Harry Merrill, Alonzo Higgins, Ed Fisher, Henry Hatch, and Andrew Bingham. They were the winning team between the "Fats and Leans" in 1904. (Albumen print, mounted; photographer's name is obscured but is probably L.N. Hibbard of Lancaster, New Hampshire.)

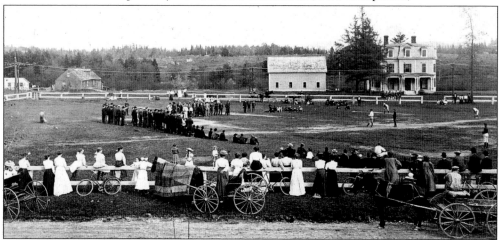

A well-attended ball game on Apthorp Common, c. 1880. The fine home on the right is that of H.C. Redington, associated with the scythe manufacturing and lumber businesses in Apthorp. (Albumen print, mounted.)

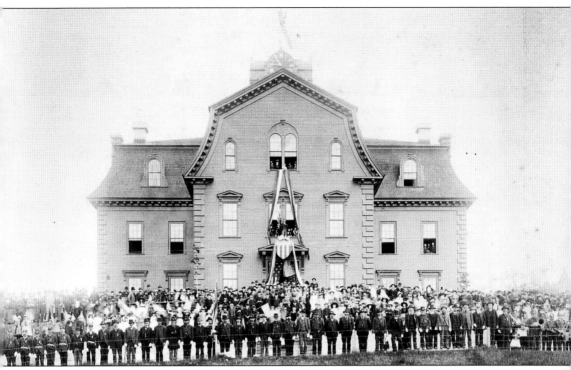

Decoration Day was of major significance (if not quite up to the Fourth of July) to a young country still licking its wounds from the terrible Civil War. The old high school, with its clock tower donated by B.W. Kilburn, wears new flags from the same benefactor. The men in the front row are presumably Civil War veterans. (Albumen print, mounted.)

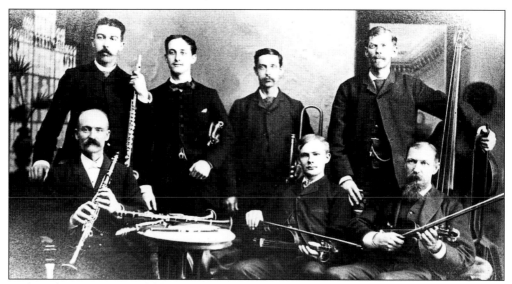

Little information is available about this distinguished-looking chamber group except their names, written in faded ink on the mounting board. From left to right are: (front row) ? Haskins, G.E. Graham, and H.H. Lovejoy; (back row) E.F. Hall (the photographer), H.E. Parker, unknown, and E.F. Cheney. (Albumen print, mounted; the size (13 1/2-by-16 inches) and the quality of the print suggest it may have been made in the Hall Studio.)

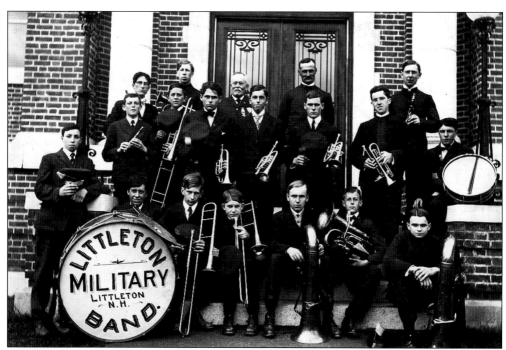

A later brass band photographed on the steps of the library. (Gelatin silver print, mounted.)

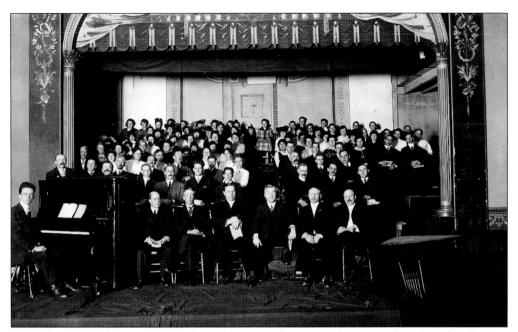

Revival meetings like this one in the 1930s were a happy combination of stirring choral music and energetic preaching. This appears to be a highly respectable example of the art form with well-loved local pianist and organist Edward Lane and the ministers of the town in the front row. (Gelatin silver print.)

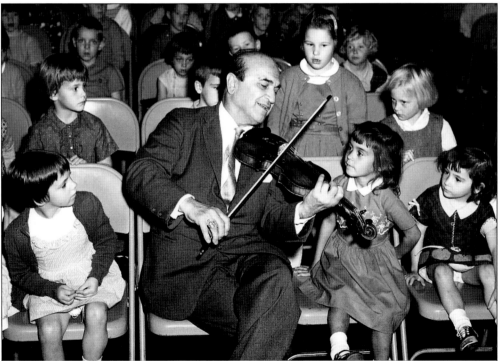

In more recent times a musical visitor was Rubinoff who utterly enchanted children in his audience with the magical sounds of his violin.

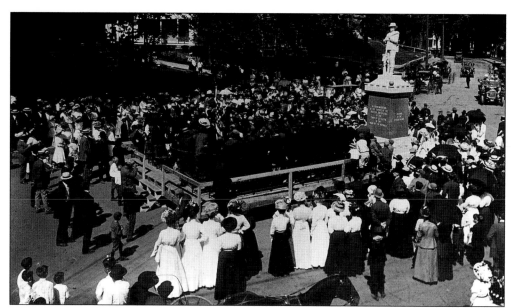

The two photographs on this page may seem unrelated but they express a continuity of community pride and service. The above photograph is the dedication of the Soldiers Monument, presented to the town by the Tilton family in 1911 and placed in front of the Town Building. It was later moved to the entrance of the Glenwood Cemetery when trucks became too large and numerous to negotiate the corner safely. (Gelatin silver print, mounted.)

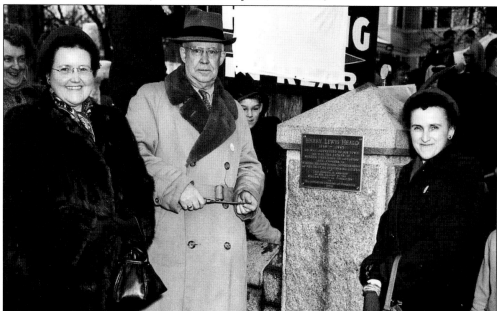

A well-deserved tribute to Harry L. Heald, a long-time citizen who contributed immeasurably to the health, happiness, and progress of his town. The plaque is installed at the entrance to the Community House, which he was largely responsible for creating, and is symbolic of the many benefits he conferred upon the community. Shown here with Postmaster Harold Young are the daughters of Judge Heald, Mary (left) and Frances, themselves outstanding exemplars of his philosophy of service.

Five

Winter in the North Country

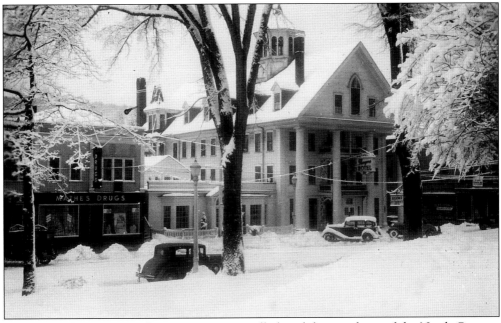

Winter—with its snow and ice—is not universally loved, but residents of the North Country have learned long ago not only how to cope with its problems but how to enjoy to the fullest its wonders and beauties. More recently, they have learned how to make it profitable as well. This section gives glimpses of how one town has accomplished this. In the above photograph, a snowfall in 1950 drapes the landscape and Thayers Hotel in, to coin a phrase, a mantle of beauty. (Gelatin silver postcard.)

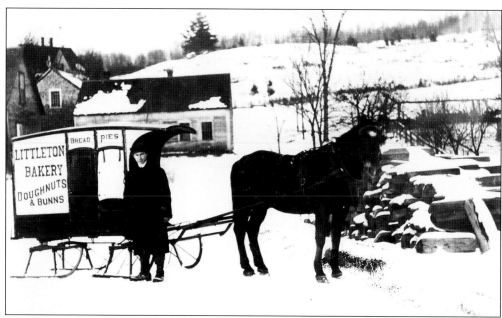

Before the horse was permanently displaced, runners replaced wheels on many vehicles to move smoothly over the packed snow that paved the streets. Arthur Bilodeau is shown here, *c.* 1910, with the wagon that delivered bread, pies, doughnuts, and "bunns." (Gelatin silver print, probably a copy.)

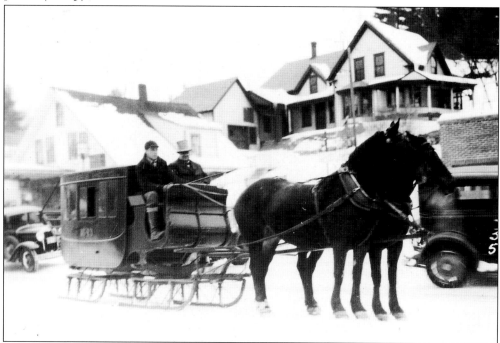

Even when cars became fairly common, many were "put up" (on blocks to save the tires) for the winter as horse-drawn sleighs were more practical before streets were kept clear of snow. Thayers Hotel transported its guests in this closed conveyance to give some protection from the cold. Note the horse's breath. (Gelatin silver print.)

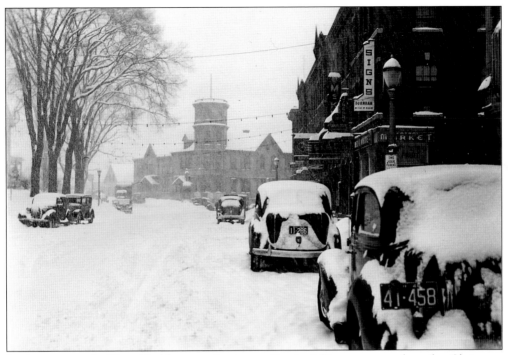

Looking east to the Town Building, nearly obscured by the falling snow two days after Christmas in 1946. (Gelatin silver print.)

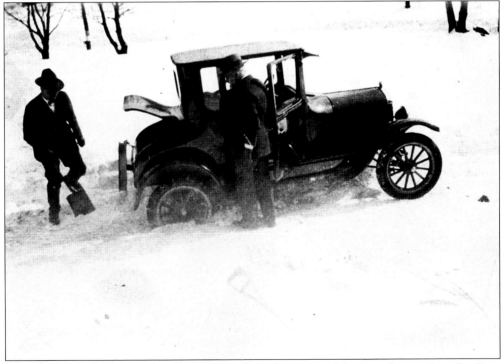

A medical consultation on the advantages and disadvantages of the horseless carriage. Dr. Page is offering Dr. Downing some probably unwanted advice. (Copy of a gelatin silver print.)

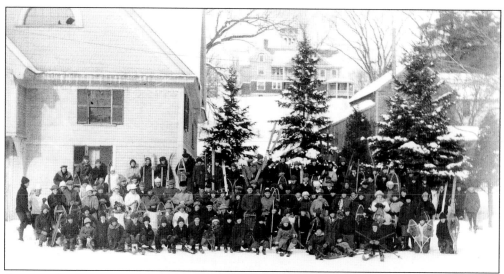

Again under the irrepressible and seemingly inexhaustible Harry Heald, Littleton not only put up with winter but began to enjoy it through the formation of the Outing Club. Members of this group—men, women, and children—donned snowshoes and skis and hiked for miles around, stopping for cookouts at various cabins built for the purpose. (Gelatin silver prints.)

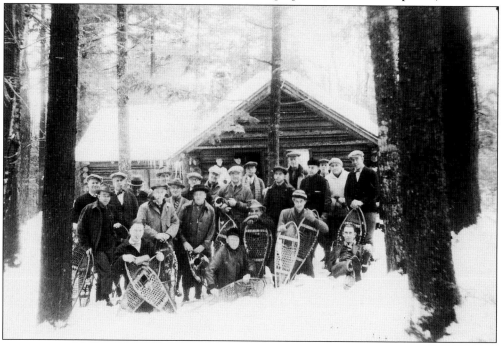

Harry Heald and another energetic organizer and entrepreneur of the period, Jack Eames, on an Outing Club trip to Black Brook Camp in March 1926. (Gelatin silver print.)

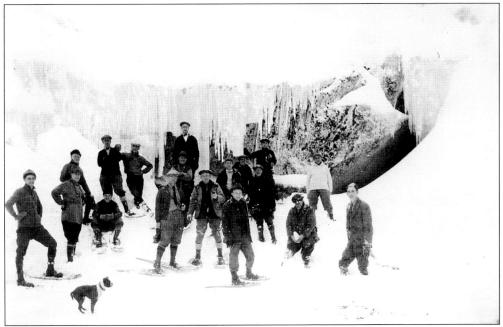

A group of Outing Club members at Bridal Veil Falls on the western slope of Cannon (Profile) Mountain. This is a fairly stiff climb of some 2.5 miles from the highway (Route 116). One wonders if the dog is regretting not having brought an extra jacket. (Gelatin silver print.)

Skiing, to borrow Dartmouth ski coach Otto Schnieb's phrase, became "a way of life" to many a young Littletonian even in the days before lifts and double poles. (Gelatin silver snapshot.)

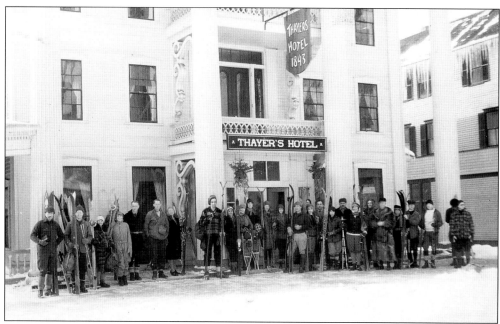

With the advent of the Boston & Maine Snow Train in the 1930s down-country outdoor enthusiasts came flocking to the New Hampshire hills. Plentiful among the early groups were those who preferred the tried and true snowshoe to the new-fangled boards but it wasn't long before the skis prevailed. Some of the trains carried a rental car where, for a price, you could be outfitted en route. Fortunately there weren't many lifts in those days so not too many tyros found themselves atop a mountain with no way to get down except walk. (Gelatin silver print.)

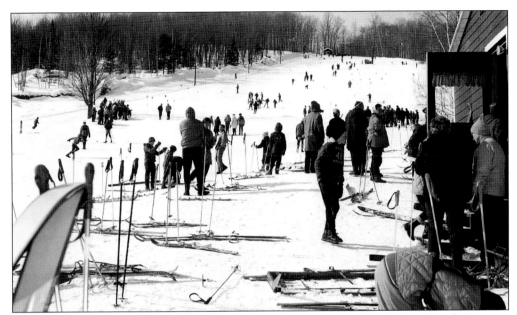

With the invention of the rope-tow, ski areas began to crop up in hundreds of North Country communities, Littleton included. Mount Eustis, on the edge of town, made an ideal ski slope and was very popular until the development of nearby Cannon Mountain, with its glorious Aerial Tramway and the more sophisticated lifts like the "he-and-she" (T-) bar, drew the enthusiasts. (Gelatin silver print.)

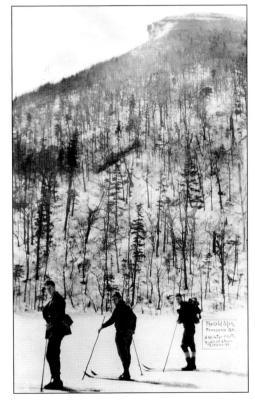

Skis were first a means of getting around over deep snow and much recreational skiing in the early days was "touring," i.e. hiking on skis. This trio is standing on ice-covered Profile Lake below the famous Old Man. (Gelatin silver postcard.)

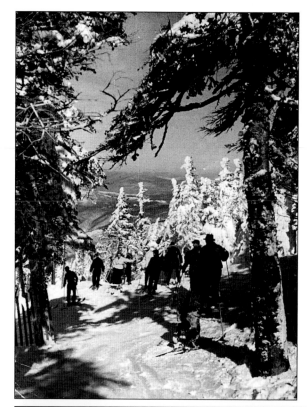

The Taft Race Trail on Cannon Mountain was cut in the days when the skier had to climb what he was going to descend. Even so there were many who gained the reward of the beautiful frost-feathered trees that are typical of this mountain. Contrary to what one might think, the frost builds up into the wind as the frozen droplets are deposited. (Gelatin silver print by Arthur Griffin, Boston.)

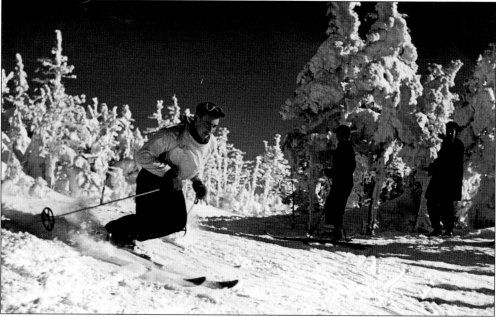

Races on the Taft became a standard event in the early days of a Boston ski club with a German name that many found difficult to pronounce—Hochgebirge. It is perhaps the oldest still-active group of its kind in the country. They promoted good technique and all-out effort. (Gelatin silver print by Arthur Griffin, Boston.)

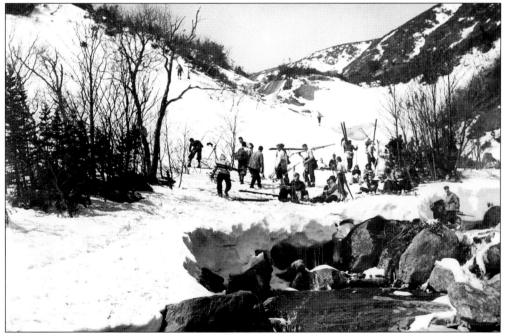

The mecca for spring skiing was, and is, Tuckerman Ravine near the peak of Mount Washington. (True, Mount Washington is not Littleton but it is a near and closely-related neighbor so hopefully we may be forgiven for including it in this collection.) Thousands every year make the long climb up from the Pinkham Notch Highway at least to the floor of the ravine or perhaps as high as "Lunch Rocks" to watch the skilled or foolhardy who have climbed varying distances up the headwall and must descend in one fashion or another. (Gelatin silver print.)

The entrance to the ravine proper is known as the "Little Headwall," which is just high enough to conceal the real headwall at this point. From here, if there is sufficient snow, it's an easy run down to the highway, a very pleasant change from the two to three hour climb up. (Gelatin silver print.)

Skating did not rival skiing but the rink at Remick Park nevertheless provided many happy hours of fun and exercise to the young and not-so-young. (Gelatin silver print.)

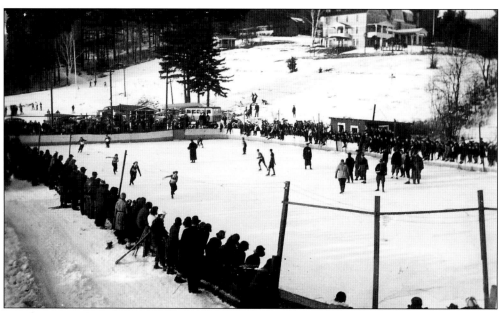

A girls' race at the Remick Park rink, perhaps in conjunction with the Winter Carnival, draws a number of spectators.

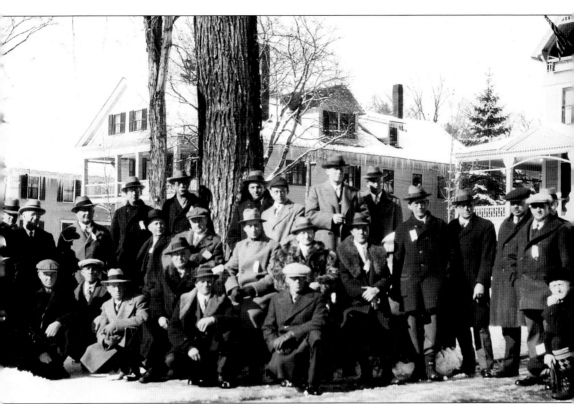

Another success story in Harry Heald's long list of innovations was the Winter Carnival, which included sports events, fun races, and a float parade participated in by most of the town's merchants. It was capped by the crowning of the Carnival Queen, who had to be a paragon of beauty and ability (one of the winners, Margaret Doyon, went on her beauteous way to become Miss New Hampshire). The popularity of the program is attested to in the above photograph, showing the selectmen of various surrounding towns gathered for the big event. Harry Heald is kneeling at the lower right. (Gelatin silver print.)

The floats ranged from the ridiculous to the macabre, but it was all in good fun.

START NOW WITH OUR LAY-AWAY PLAN!
$10. a month as long as you live...
and we'll arrange transportation
either UP or DOWN!
WE'LL FURNISH YOUR HOME THE SAME WAY!
FRANCONIA ASSOCIATES

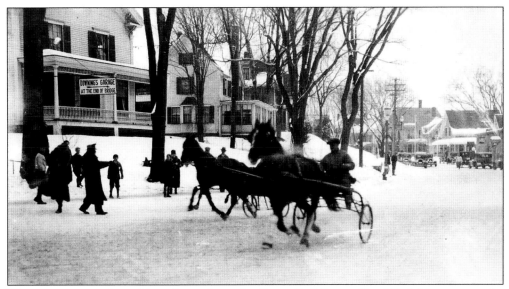

The trotting race down Main Street from the Town Building to Dr. Giles' (the present site of Dunkin Donuts) was an exciting event requiring police assistance to keep the road clear. (Gelatin silver print.)

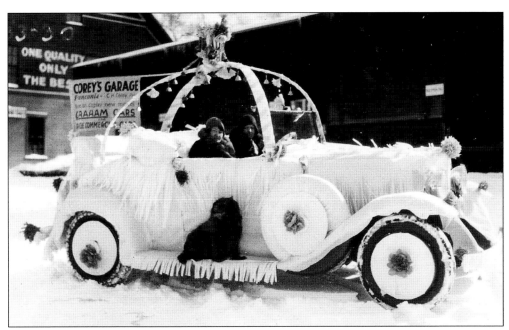

An imaginatively decorated roadster, no doubt with rumble seat, carries, in addition to the dog, two ladies wearing cloche hats. (Gelatin silver print.)

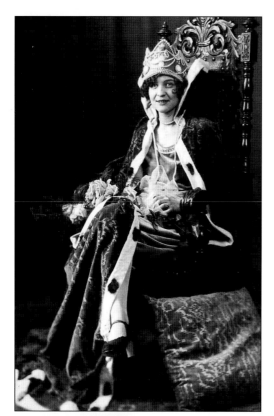

The 1928 Carnival Queen was Marion Willett, seen here in her regal robe and jewelled crown which were presented to her on the velvet cushion at the lower right. The material for the robe and cushion is said to have been donated by funeral director Charles F. Bingham. (Gelatin silver print.)

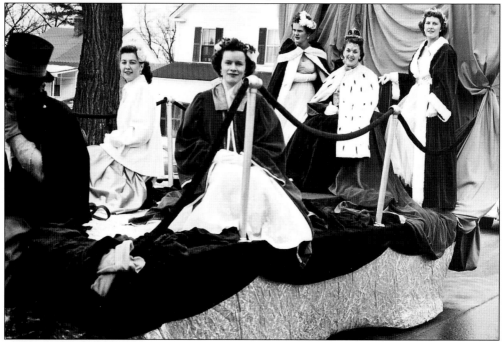

Carnival Queen Betty Hicks and her court are paraded down Main Street to be viewed by the admiring crowd. (Gelatin silver print.)

86

A snow sculpture on the library lawn.

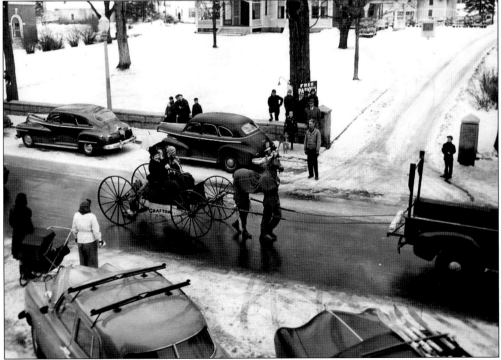

The wagon is authentic but there is some doubt about the horse.

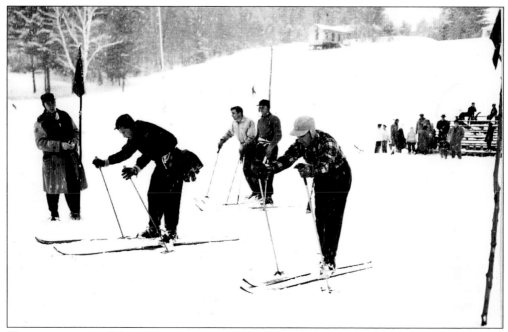

Ski competitions at Mount Eustis were a major feature of most carnivals.

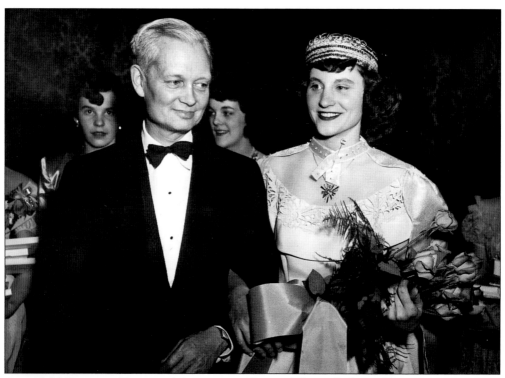

A youthful Governor Sherman Adams escorts Carnival Queen Roberta Christie.

Six

Church and School

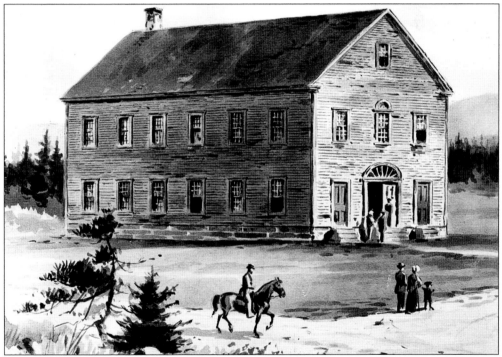

The first Littleton Meeting House, a barn-like structure typical of early New England meeting houses, was erected in 1812 and was multi-denominational, each group being allowed its own minister and allotted a fair share of time. It was located, as required by the terms of the charter, as close to the center of the grant as seemed practical, but as things turned out the town developed along the Ammonoosuc River, leaving the Meeting House about 2 miles from the center of population. The building was barren of furnishings and unheated until 1822, when Reverend David Goodall donated a stove (for self-preservation?) with the provision that the parishioners supply the necessary pipe.

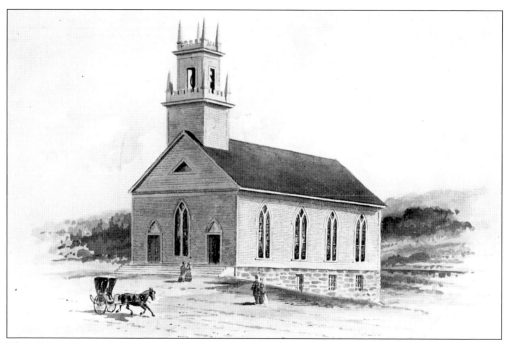

The Congregationalists were the prime movers in the erection of the Meeting House, and in 1833 they became the first to build their own church, located in the village center at the site it still occupies today.

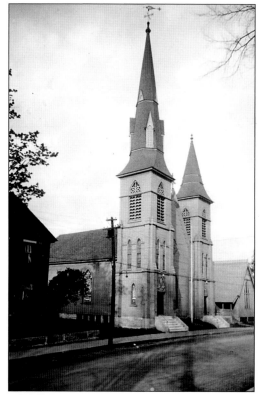

Major improvements were undertaken as the church flourished. In 1874 the building was remodeled and the distinctive twin spires added, making the church a welcoming beacon to approaches from the west. (Gelatin silver print.)

Major interior alterations were undertaken starting in 1943 when the chapel was renovated and other significant improvements made. (Halftone print.)

Both the Congregational and Methodist churches have magnificent stained glass windows manufactured by Redding and Baird of Boston. They have been described authoritatively as "irreplaceable," which makes it all the more wonderful that in the 1924 fire near the Methodist church—a blaze described as "the worst in Littleton's history," which cracked plate glass windows "blocks away"—not a single stained glass window in the church was damaged. They are indeed a matter for community pride and those who guard and care for them are owed a debt of gratitude. (From "First United Methodist Church" by Linda McShane.)

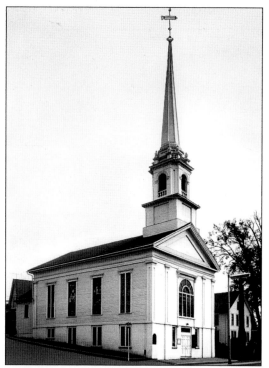

By 1850 the Methodists, who had been meeting mostly in private homes (perhaps finding them more comfortable than the unfurnished and ill-heated Meeting House) purchased the lot at the corner of Main Street and Mann's Hill Road (now Pleasant Street) and proceeded with the construction of a handsome building. Standing at the east end of town, it balances the Congregational church in providing a beacon for people approaching from the south and east. The original building was Greek Revival in style with two fluted columns. These became structurally unsafe and were removed in 1888, a change that did not meet with universal approval but insured the safety of the structure. (Airbrushed gelatin silver print.)

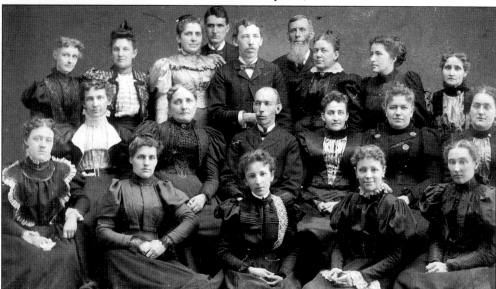

A Methodist group of the 1880s. The nature of the group is unknown but one suspects it might be the choir as the organist is identified and the paucity of men is typical of many church choirs. From left to right are: (front row) Alice Eastman, Mrs. Arthur Buffington, Mrs. Jennie Bedell, Mrs. Eben Cole, and Mrs. Robert Langford; (middle row) Mrs. Wm. Silsby, Mrs. Henry Parker, the Reverend Chas. M. Howard, Mrs. C.W. Howard, Mrs. George Edson (organist), and Miss Bessie Edson; (back row) Mrs. D. Abbott, Mrs. Ira Parker, Mrs. Ray Gile, Supt. Harry Witham, Arthur Buffington, George Cowen, Mrs Frank Phillips, Mrs. Dan Cole, and Mrs. I.C. Richardson.

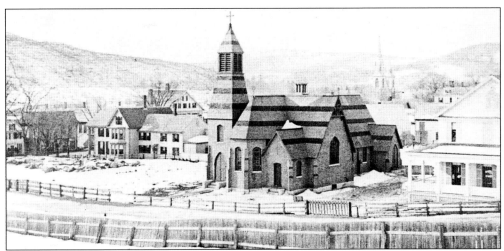

Members of the Episcopal denomination first conducted services in Littleton in 1859 as guests of the Congregational church. In 1872 the Methodists were the host church for a visit from Bishop Niles. By 1875, with considerable help from the Ladies Guild, the organization had progressed to the point of laying the cornerstone of the fine building seen here, a bit of Old England in a "New" setting. The twin spires of the Congregational church may be discerned at right. (Reproduction print.)

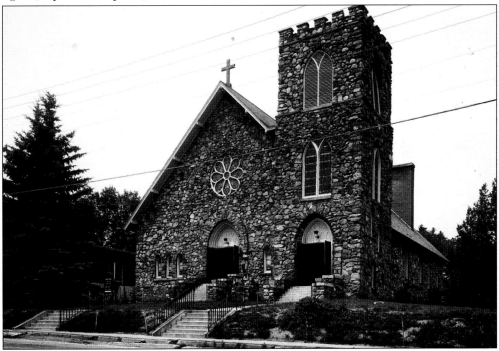

The first Catholic church was a wooden building on the corner of High and Clay Streets. Built in 1877, it was dedicated in 1880 under the name of St. Rose of Lima, the first saint canonized in the New World. The present fieldstone structure (shown here) was built on the same site in 1913. There is a touching tradition that church members carried stones from their own fields and left them at night for the masons to use the next day. (Gelatin silver print by Lawrence F. Presby, Ltn.)

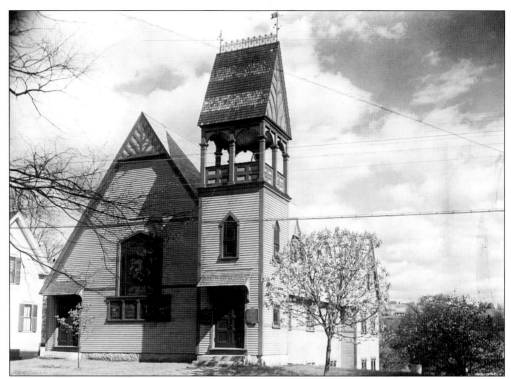

The building above was erected by the Unitarian Society in 1887. In 1954, that society having disbanded, the building was purchased by the Lutheran Church and still later by the Baptists. It was destroyed by fire in 1976 and has been replaced by a new Baptist church.

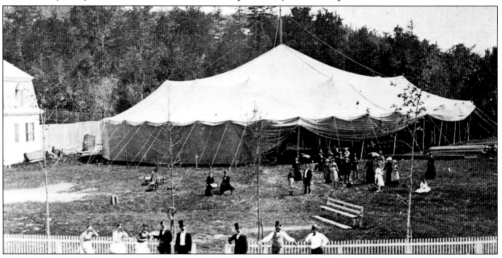

Revival meetings were popular in the late nineteenth century, combining as they did religion, discussions of the social problems of the day, and the relaxed atmosphere of the outdoors. Henry Ward Beecher, a Congregational preacher and orator who spoke eloquently on the vital issues of the time—slavery (against) and female suffrage (for)—used this tent in Twin Mountain during a visit to the region. He preached from the pulpit of the Congregational church in 1856, probably around the time of this photograph. (Original unknown; reproduction print by Lawrence H. Presby, Ltn.)

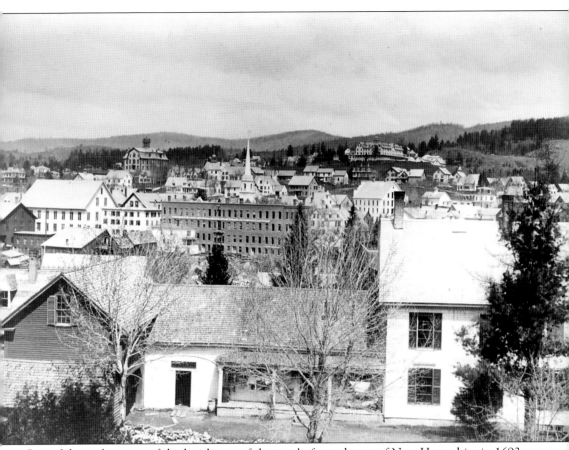

One of the earliest acts of the legislature of the newly-formed state of New Hampshire in 1693 required the towns to build schoolhouses and supply teachers. By 1791 the struggling little community of Littleton voted to establish a public school and from that time on education has been a primary concern of its citizens. Many small "district" schools were built because of the difficulty of traveling on foot during the long winters. With the growth of the village, the population became more concentrated and "Union" districts were created, making possible larger and better schools with more than one teacher. The above photograph, probably taken from the Kilburn factory, shows the old high school standing proudly on the hill at the left center. Built in 1868 it was surely an impressive advance for a town that only a hundred years before had been wilderness. Other prominent landmarks are the Oak Hill House (the highest building right of center), the spire of the Methodist church, and the glove factory (directly in front of the Methodist church). (Albumen print, mounted; B.W. Kilburn, Ltn.)

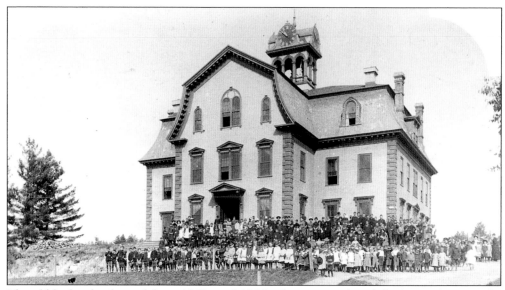

The old high school stood from 1868 until 1926, when it was demolished to make room for the present-day building erected on the same site. The old building was said to be one of the finest school buildings of its day in New Hampshire. As may be seen with a magnifying glass, the school included all grades from one to twelve. (Albumen print, mounted; A.W. Currier, "Photographic and View Artist," Mechanic Falls, Maine.)

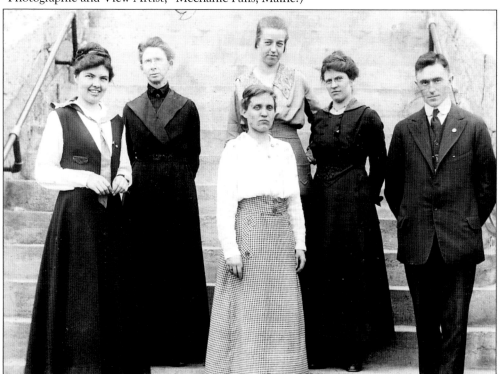

The high school faculty in 1918–19 included, from left to right, Britamate Somers, Stella Osgood, Helen Bosworth, May Foster (in front), Marion Evans, and Stephen A. Doody, principal.

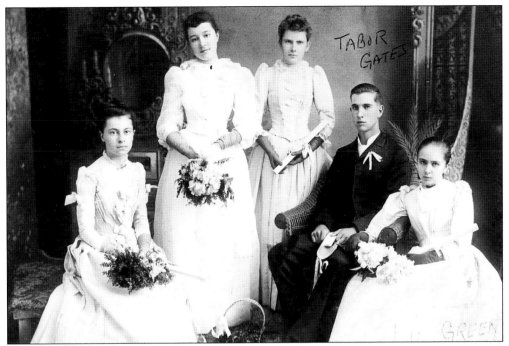

The graduating class of 1890. Only two are identified, unfortunately by writing on the face of the picture (!): Tabor Gates and Lil Sanger.

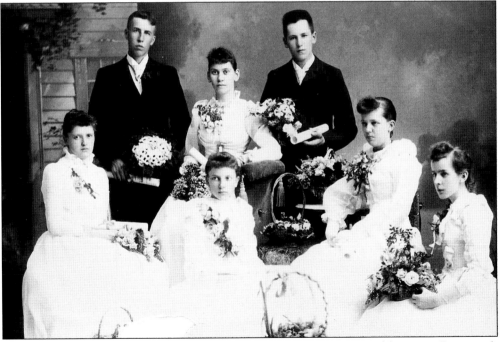

In 1891 the graduating class included two young men, one of whom would go on to Dartmouth College and complete medical school. From left to right are: (front row) Myra Farr, Addie Gates, Gertrude Farr, and Jane Tuttle; (back row) William Kenney, Mary Baldwin, and John M. Page (later Doctor Page who would practice here for many years.)

This tasteful arrangement for the class of 1899 includes, from the top, Nellie Heald, Bessie Kinne, Wilmer Leach, Margaret Matheson, Elizabeth Porter, Amy Churchill, and Ada Dow. (Albumen print in an embossed mount.)

SENIOR ⊠ CLASS RECEPTION.

1895.

· · · PROMENADES · · ·

1.	Class of '95 March	*Sousa*
2.	To the Field of Honor	*R. Schlepegrell*
3.	Amicitia	*G. Weigand*
4.	Home from Camp	*E. N. Catlin*
5.	F. S. B.	*G. Schulze*
6.	Thunderer (ladies' choice)	*Sousa*
7.	Manhatten	*Sousa*
8.	A. O. U. W.	*D. W. Reeves*
9.	The Review Guard	*G. R. Armstrong*
10.	Immer Die Ersten	*C. Hoch*

The dance card suggests the formality of the day as do the dress and mien of the graduates. The military flavor of the program probably stems from the impending Spanish-American War.

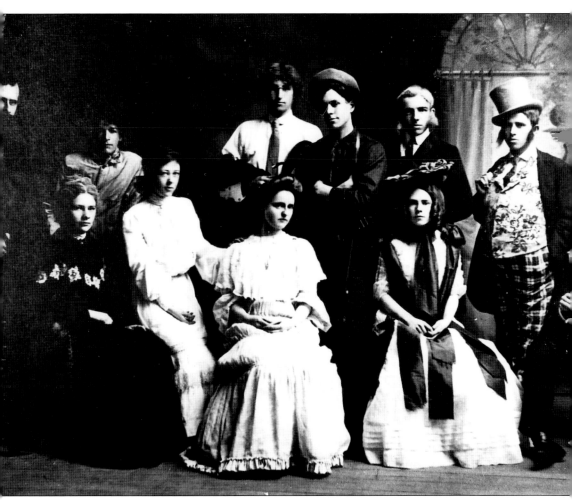

The high school curriculum broadened over the years from the basic courses in languages, mathematics, science, and history to include music and such activities as debating, dramatics, sports, and a school publication, *The Record*. The first senior class play was produced in 1904 and would appear to have been an ambitious and well-executed project. The thespians are, from left to right: (seated) Glenn Silsby, Edith Bean, Mary Richardson, Georgia Henry, and Fred Bachellor; (standing) Harry Barrett, Bill Jackson, Dick Merrill, Tom Varney, Ralph Noyes, and Clarence Morgan. (Gelatin silver print, mounted.)

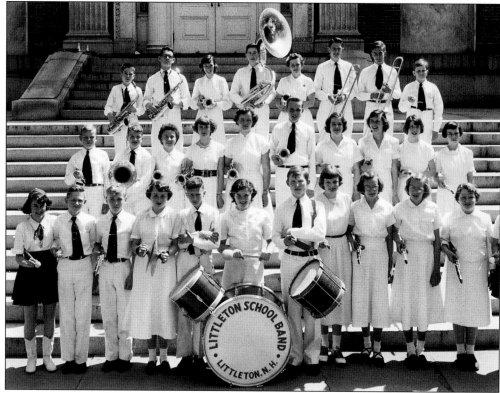

A school band was inaugurated in 1951. This photograph was taken May 1 of the following year when the band marched in the Burlington (Vermont) Music Festival. Uniforms would come later. (Gelatin silver print.)

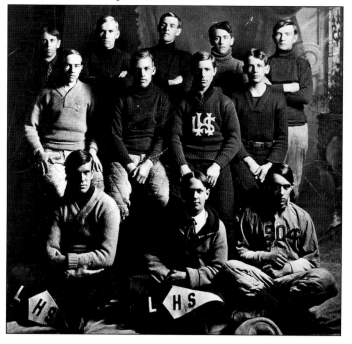

Athletic programs for boys were started early, baseball, football, and basketball being favorites in interscholastic competition. The only person positively identified in this 1907 photograph is Arthur "Peb" Strain (back row, second from the left).

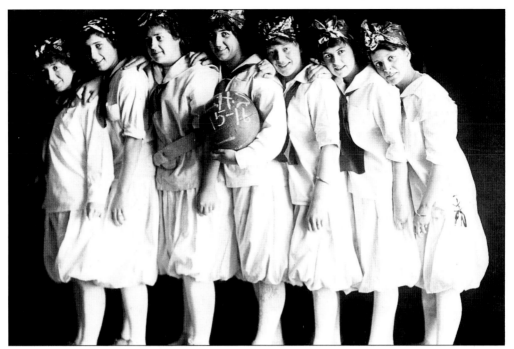

Girls soon got into the athletic act as can be seen in this 1915–16 photograph of a group of husky hoopsters. (Gelatin silver postcard.)

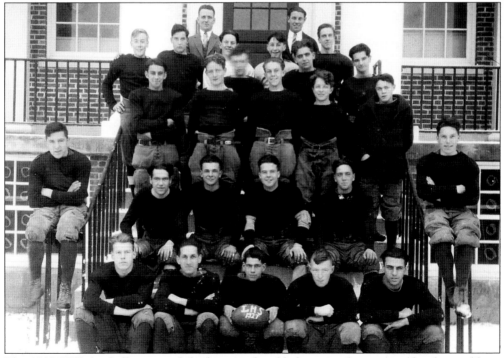

The 1927 LHS football team with high-waisted padded trousers but not much other padding. It must have been an early winter this year. (Gelatin silver print in formal mount; White Mnt. Studio, Ltn.)

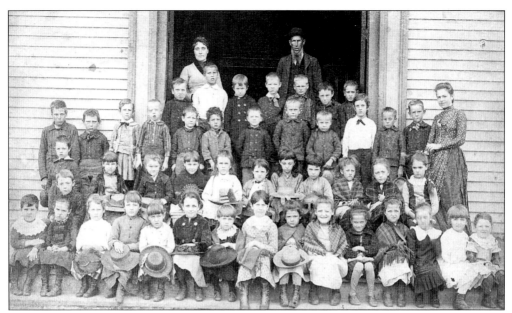

In 1905–1906 Littleton still operated eight rural district schools. This one unfortunately is unidentified but would surely seem to be of nineteenth-century vintage judging from the attire. (Albumen print, mounted.)

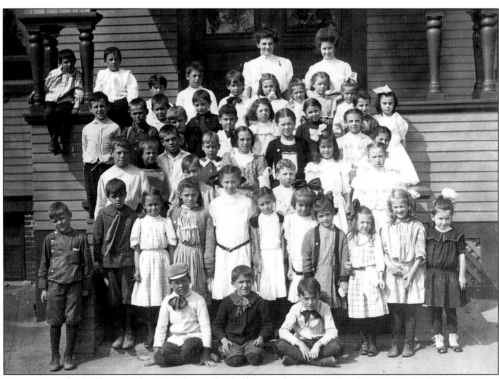

A group at the Kilburn School built on the hill near the high school in 1889. (Albumen print, mounted.)

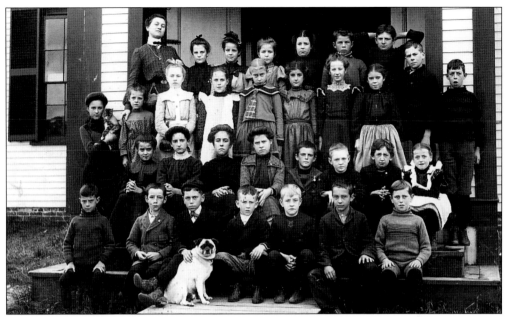

The teacher, pupils, and pets (note the cat held by the girl at left) at the Mitchell School, built on the South Side in 1827. (Albumen print glued to an album page.)

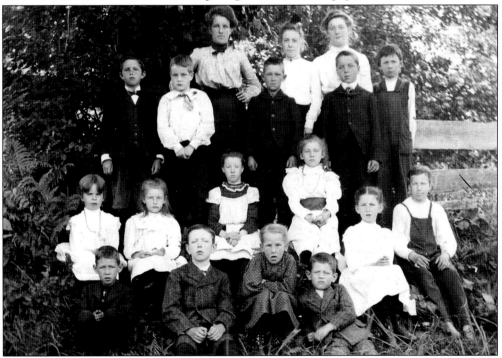

West Littleton School pupils c. 1904. From left to right are: (front row) Guy Kinne, Charles Carpenter, unknown, and Richard Carpenter; (second row) unknown, Stella Chandler, Carrie Marden, unknown, Fannie Carpenter, and unknown; (third row) unknown, Roy Astle, Charles Kinne, unknown, and unknown; (back row) Marion V. Morse (teacher), Alice Stevens, and Frances Astle. (Albumen print, mounted.)

In September 1914 manual training courses were begun for both boys and girls in grades seven and eight. The pride in their accomplishments is manifest especially in the face of the boy at left front who seems to have done double duty. (Gelatin silver print, perhaps not original.)

Guy E. Speare became the principal of the high school in 1910 and later the superintendent of schools. He was a well-respected leader and innovator who pushed for broadening the curriculum to include vocational and technical subjects, and hence came to be dubbed "The Prof." On the back of the picture in Mr. Speare's handwriting and signed by him, is the following: "Telescopic Preparedness. One can at least look 'Over the top.'" As this was written in 1916, one assumes it is a reference to the trench warfare going on at the time in Europe. (Gelatin silver print.)

Seven

The Stereograph

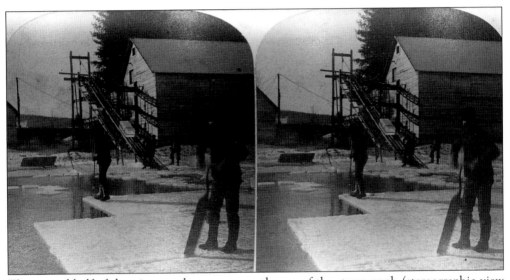

The second half of the nineteenth century was the era of the stereograph (stereographic view card) and the stereoscope (viewing instrument). These twin-picture cards were manufactured by the millions at first in Europe then even more widely in the U.S. (at one point there were 18,000 stereographers at work in North America alone). The era came to a close with the advent of the moving picture, but while in vogue the stereograph had a tremendous impact on the world, which for many was restricted to how far they could walk, ride a horse, or paddle a boat. In Boston Oliver Wendell Holmes, physician, teacher, poet, and writer on many subjects, developed a new viewer, the hand stereoscope, which he had manufactured by local artisan Joseph L. Bates and which became the world standard. There were other types of viewers of course such as the "Grand Parlor Stereoscope" made by Southworth and Hawes in Boston and advertised for $11,600 (a fortune in those days). The cards were the TV of the day; how a small town in northern New Hampshire could make the impression it did on an enterprise of such scope, if not a mystery, must at least be conceded to be a wonder. The photographs and captions to follow will attempt only the briefest sketch of this phenomenon.

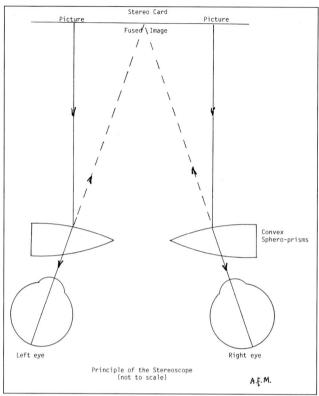

Principle of the Stereoscope
(not to scale)

The stereoscope was invented and named by British scientist Sir Charles Wheatstone in 1838, a year before the photographic process was announced. He did his work with painstakingly hand-drawn pictures. The instrument he devised used mirrors to view the two pictures and was later improved by Scottish physicist Sir David Brewster by substituting lenses for the mirrors. This provided the basic form for all stereoscopic devices. The secret of how this device makes two 2-dimensional (flat) pictures appear as a single 3-dimensional image lies in the fact that the two originals are not identical. They are made by photographing any object or scene with a special form of camera having two lenses, each of which produces a picture. Because the lenses are separated by some 3 inches they produce slightly different pictures, one lens "seeing" more on the left, the other more on the right. This is readily demonstrated by taking an ordinary stereograph and measuring, with as much accuracy as possible, the separation between two sets of corresponding points, one set that is far away in the original scene and one that is close. Using the stereograph on the preceding page as an example, if we measure on the original card (the reproduction is a little smaller) the separation of the poles in the left background we find it to be 3.15 inches. Then, measuring the separation of the points where the ice saw disappears, we find it is 3.01 inches, a difference of slightly more than 1/8 inch. This may not seem like much but the adjustments the eyes make in looking from one point to the other create the illusion that the saw is very much closer to us than the pole. It is perhaps not strictly correct to describe this as an "illusion." If we looked at the actual scene—our eyes being separated by about 2.5 inches—our brain receives two slightly different pictures; it is the fusion of these two images in the brain that gives us our marvelous faculty for seeing in depth—stereopsis.

The diagram above illustrates how the stereoscope works. Each eye sees only one of the twin pictures on the card; the two slightly dissimilar images are fused in the brain resulting in the third dimension effect.

Note: All the stereo cards used in this section show only one half of the card in order to achieve a larger picture.)

Franklin Weller was a carriage maker and decorator in Littleton (see p. 4). He was also a musician, being for some years the leader of the Littleton Brass Band (the uniform of which he is wearing here). He was obviously a man of talent and imagination as he also became interested in stereography, which he studied with Franklin White. In 1867 he purchased an interest in White's business.

Franklin White of nearby Lancaster, New Hampshire, was a landscape painter and photographer who turned his attention to stereography when the art form was still in its early stages, and began making daguerreotype stereographs in the 1850s. He later tried glass plates, and eventually paper prints mounted on cards, an example of which is shown above. (Half-stereo by Franklin White entitled "Interior Summit House, Mt. Washington, Feb 11 1862.")

Edward Kilburn had been trained to enter his father's foundry business but evidently found his interests lay in other directions as he became an apprentice to Littleton's first resident photographer, O.C. Bolton, and opened a studio before the war. How and when he learned about stereophotography is not precisely known.

Benjamin Kilburn on the other hand remained in the foundry (it is interesting to note that the company name was "Josiah Kilburn and Son). He served briefly in the army and at the close of the war in 1865 joined his younger brother in establishing a "stereo view manufactory." Ben was a great outdoorsman and, substituting a stereo view camera for his gun, roamed the familiar hills and scenic spots. Within a year the brothers had put together a series of 175 views "mostly of the White Mountains." A set was sent to the prestigious magazine the *Philadelphia Photographer*—and the Kilburn name was made.

108

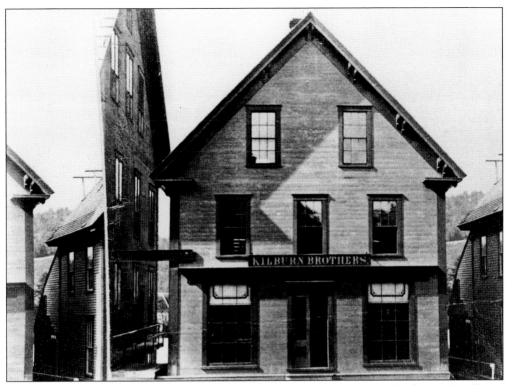

Business expanded so rapidly they moved from Edward's studio to a factory built on Main Street in 1867. The back (south) side had another floor below street level due to the slope of the terrain, offering more windows where the prints were developed by sunlight.

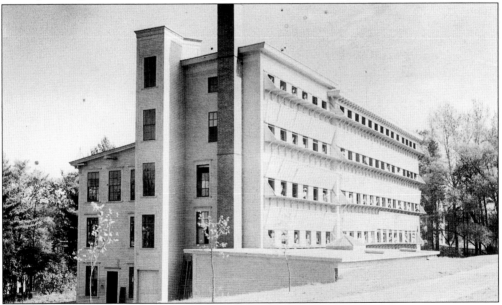

By 1873 another move became necessary and the brothers built a new, larger plant on Cottage Street. The building stands on the same site today but is now an apartment house. The only glimmer of its great glory is a state historic marker on a post at the corner of Kilburn Street.

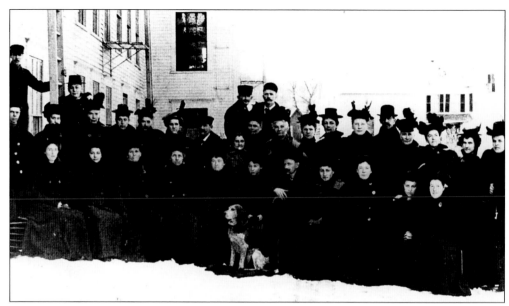

A group of Kilburn workers gather outside the Cottage Street factory. They were mostly women (deft fingers?) with a sprinkling of male supervisors or technicians. Women were paid $2.00 to $2.50 per week, the men more.

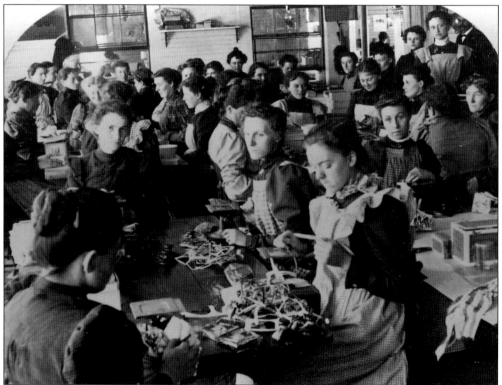

The cutting department in the Kilburn factory. The pictures were sun-printed on large sheets then trimmed to size with scissors or, later, cutting dies. It was mostly hand work which makes a production figure of 5,000 cards a day hard to believe.

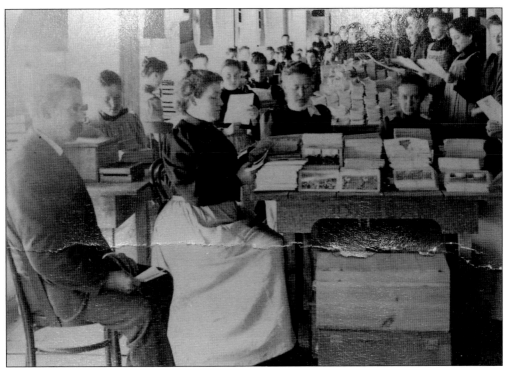

The order department gathered the cards and made them ready for shipment. The exact duties of the male supervisor are not known but he doesn't look like a Simon Legree.

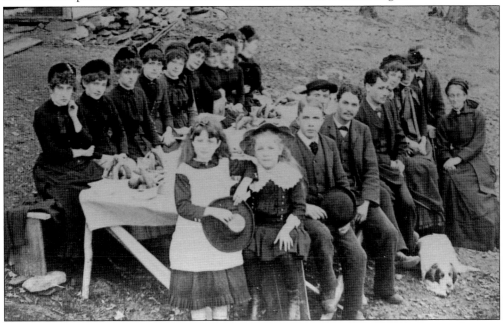

There was a little fun in the midst of 10-hour work days. At gatherings like this maple sugar party, Edward's melodious baritone voice is said to have contributed much enjoyment. However, Edward sold his share to his brother in 1875 and turned to other photographic interests and to farming.

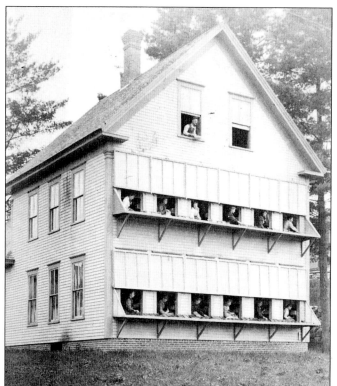

While all this was going on in the Kilburn enterprise, the business begun by Franklin Weller was developing much more slowly. For one reason or another he sold all his negatives to George Aldrich, a photographer who had moved here from a neighboring town in Vermont. Aldrich operated the business and added to Weller's negatives but later sold it to local businessmen George and William Bellows. It was then named the Littleton View Company (locally known as the "Bellows View Shop") and housed in a new factory on High Street. Note the shuttered and shelved windows to allow the exposure of the prints.

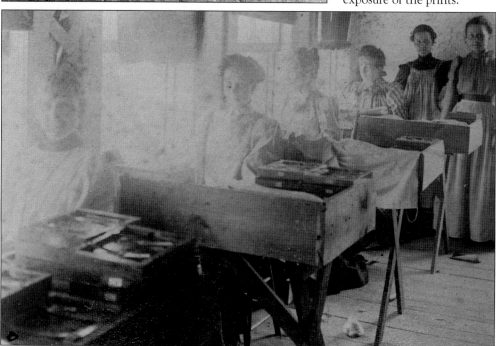

Workers in the Littleton View Shop, 1900, with sun flooding in the windows. From left to right are Jennie Dufee, Isabella Bishop, Mrs. Grant, Mrs. Cora Andrews, Clara Byron, and Delia Byron.

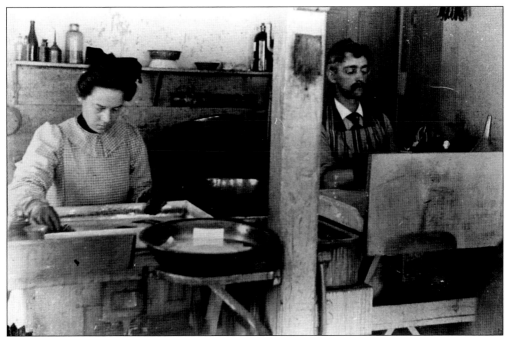

Workers treating prints. After development in frames at the windows (sunny days had to be devoted to exposing as many negatives as possible, leaving the other operations for dark periods), the prints were "fixed" to prevent further darkening which otherwise would continue until the picture was lost. After fixing, the prints were usually dipped in various toning solutions.

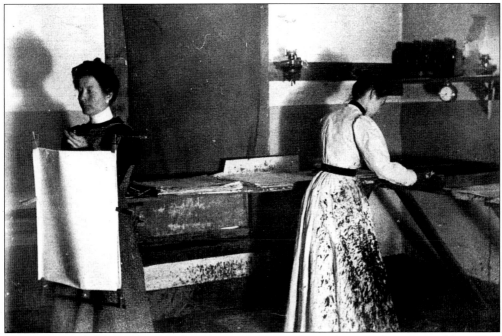

The woman at left has a sheet ready to hang for drying; the worker at right, protected by rubber gloves and heavy apron, dips prints in a chemical bath.

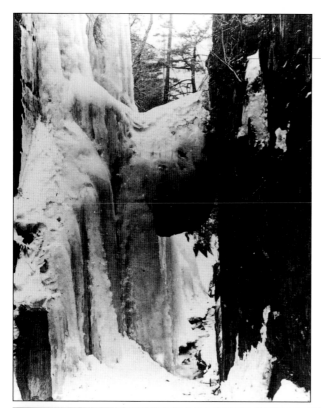

An early Kilburn Bros. half-stereograph of familiar local scenery: the Flume in Franconia Notch, before the boulder was washed away in a great flood. (Kilburn Bros., #79.)

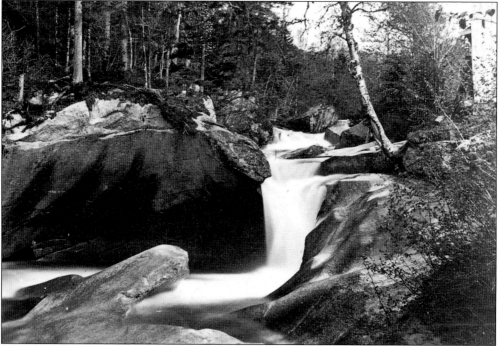

Another early local scene, the Basin. This card carries on the back the 2¢ Internal Revenue stamp that was required for a short time. (Kilburn Bros., #70.)

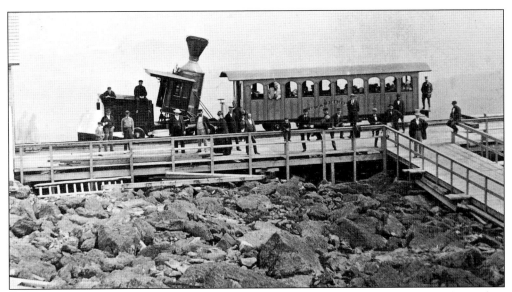

One of the early Cog Railway trains at the summit. The vertical boilers were changed to horizontal in 1878. (Kilburn Bros., unnumbered.)

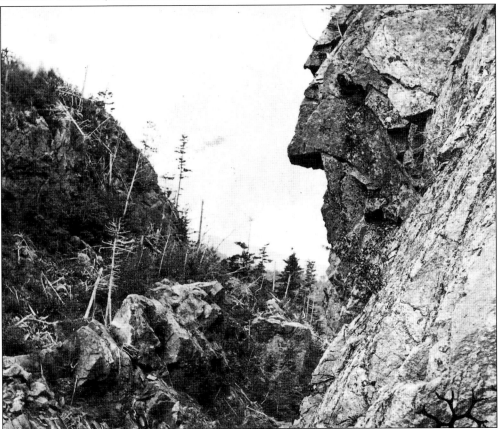

Crawford Notch before the road was built. "There were giants in the earth in those days." (Kilburn Bros., #68.)

A much copied view of the Old Man "Enthroned Among the Clouds," made after the company was "B.W. Kilburn," but oddly bearing the imprint "Copyrighted 1880 by Kilburn Bros." (B.W.K., #714.)

The old Tip Top House on the summit of Mount Washington. Judging by their attire, the visitors would seem to have arrived either by carriage or cog. (B.W.K., #406.)

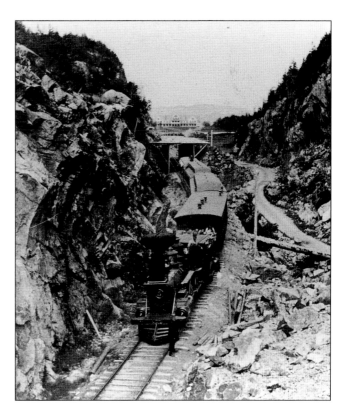

An east-bound woodburner stands at the Gateway to Crawford Notch. The famed Crawford House can be dimly seen in the distance; note the road on the right. (B.W.K., #309.)

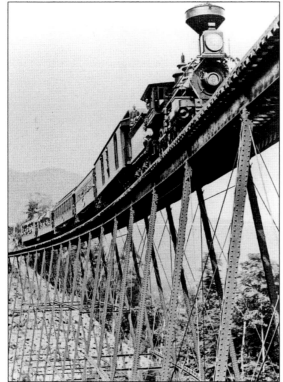

This view of Frankenstein Trestle hardly needs the aid of stereography— the perspective alone is enough to awe the viewer. A magnifying glass will show the engineer at his window and the fireman perched at the highest point of the tender! (B.W.K., #307.)

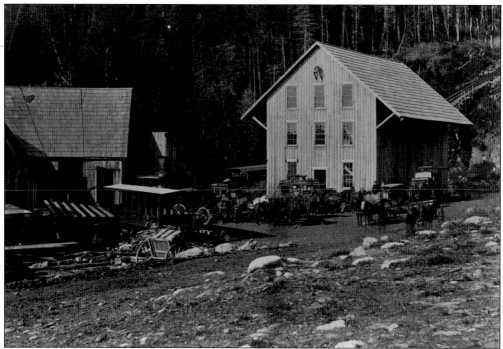

Franklin Weller's early cards were pretty much conventional scenes like this view of the Base Station of the Cog Railway, but he soon was on other tracks. (F.W., #257.)

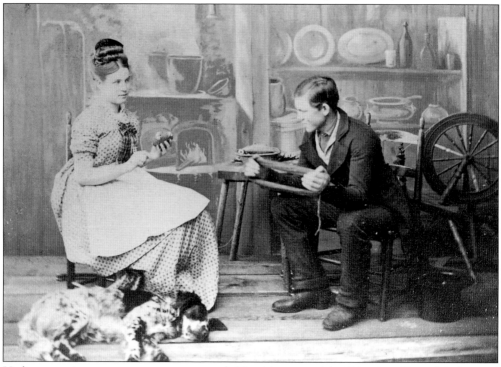

He began posing scenes to create story cards like this one entitled "Ancient Courtship," one of his well-known "Stereographic Treasures" series. (F.W., #506.)

Some were what might be described in today's parlance as "sitcoms." (F.W., #504.)

One of his innovations was the use of double exposure to create imaginary situations. This one is entitled "Artist's Dream." (F.W., #306.)

The Littleton View Company continued to publish Weller's popular cards, but added their own from other sources. Their cards were later distributed world-wide by Underwood and Underwood, who had agencies in England as well as major American cities. Titles on the cards were in English and Spanish; with an office in El Paso, they presumably reached across the border. (L.V.C., #1620.)

This card evidently appealed to the humor of the day as it was issued by several companies including Kilburn, although the Littleton View Company seemed to hold the copyright. The maid is serving the tomatoes "undressed," as per instructions. (L.V.C., #1448A.)

Eight

Beauties Overlooked

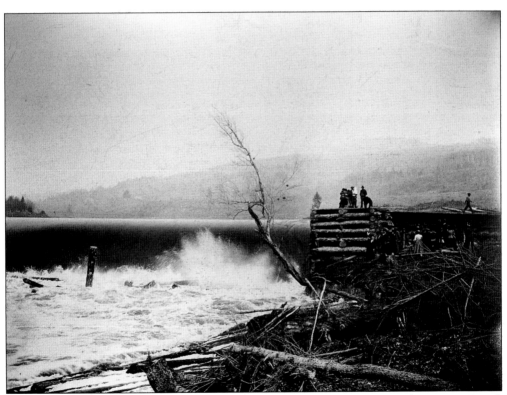

Littleton is indeed in many ways a "center" of the White Mountain region: business, cultural, and above all, scenic. Within a 50 mile radius are views that made the region one of the major tourist attractions in the country until the opening of the western mountains. For the last few pages of this book we have selected, more or less at random, a few of these scenes as frosting on the cake. In the above photograph, the mighty Connecticut River shows its muscle. (Albumen print, mounted.)

Two gems of small lakes are nestled in the intervale of Cannon (Profile) and Lafayette Mountains in the Franconia Range. The Great Profile looms over them on one side, with Eagle Cliff on the other. At the end of Echo Lake, Artists' Bluff provides an easily accessible overlook. (Albumen print, mounted.)

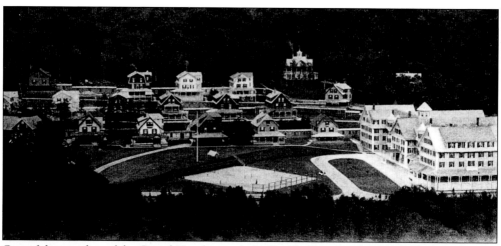

One of the wonders of the Grand Hotel era was the Profile House and Cottages built in the area between these two mountain lakes. Its grandeur rivaled its setting—the "cottages," connected by a walkway so guests could get back and forth to the main dining room without undue exposure to the elements, had up to a dozen bedrooms. (Copy print, original unknown.)

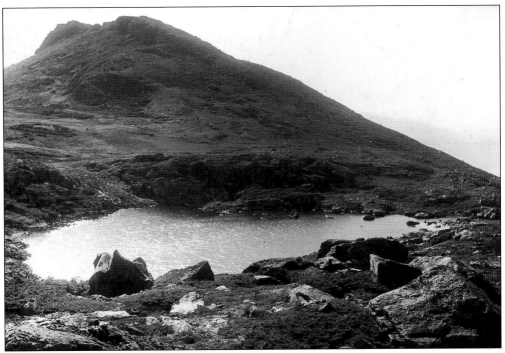

In the boulder-strewn col between Mount Monroe and Mount Washington lie the aptly-named Lakes-of-the-Clouds at an elevation of about 5,000 feet. Here arises the Ammonoosuc River which furnished the power for Littleton's early mills and accounts in large measure for its early growth and development. (Albumen print, mounted.)

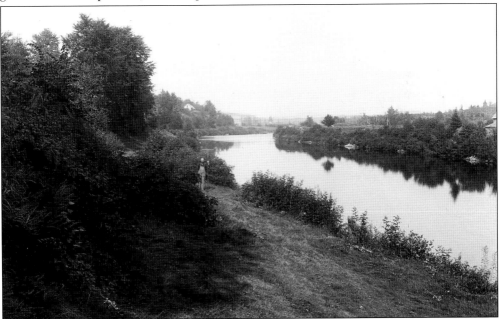

The river, on its course to join the Connecticut at Bath, is mostly quiet and gentle once it gets off the mountain, although white-water canoeists find its rocky sections sufficiently challenging during the spring snow-melt.

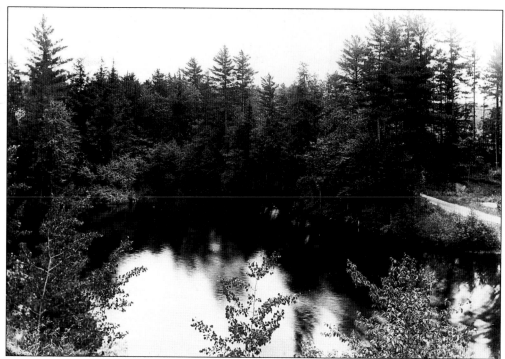

Within the borders of the town itself lies a secluded area of woodland and quiet-flowing brook known as the Dells, which was bequeathed to the town in 1917 by Daniel C. Remich to be preserved for park purposes. It is an ideal spot for nature study or just plain enjoyment. (Gelatin silver print.)

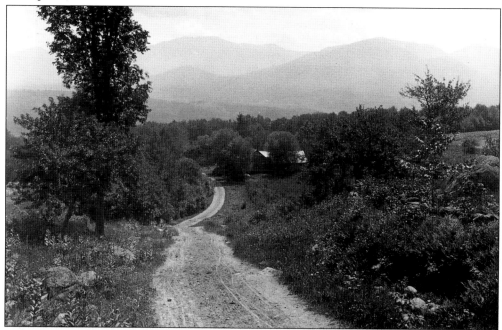

The Spooner Hill Road meanders through the valley toward the shadowed Franconia Hills, speaking eloquently of a quieter time. (Gelatin silver print.)

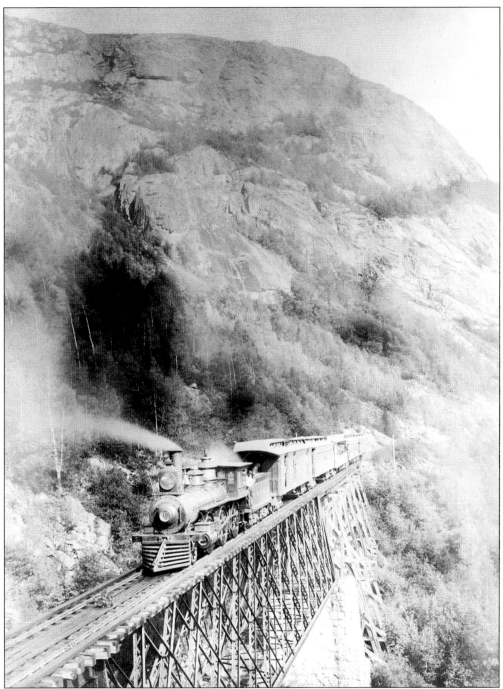

Perhaps the most mystifying thing about this photograph is where Ben Kilburn stood to take it. Barring levitation, he must have had an excellent long-focus lens. The rugged cliffs of Mount Willard rise behind the train on the Willey Brook Bridge in Crawford Notch. From the top of the mountain, which is easily reached by a broad trail built originally for burros carrying Crawford House guests to the broad, flat summit, there is an incomparable view eastward through the Notch. (Albumen print, mounted; B.W. Kilburn, Ltn.)

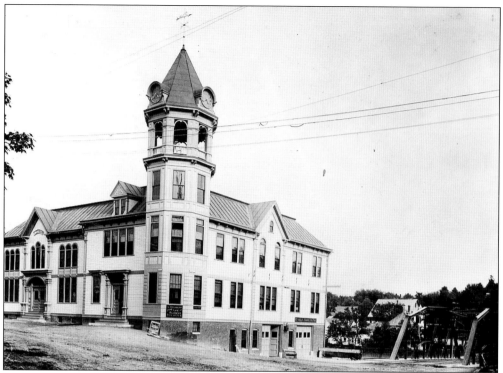

The Town Building not long after its erection in 1895. On the left is the entrance to the Opera House, the scene of entertainments of many kinds for generations of Littletonians and others. At the lower right corner of the building is the entrance to the fire station, then the Eureka Hose Company #1, now the entrance to the Museum of the Littleton Area Historical Society. (Gelatin silver print.)

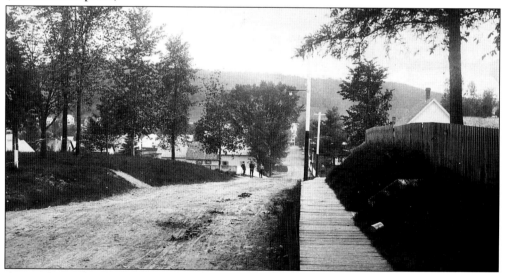

A view down Pleasant Street toward Main and the site of the Town Building, which, however, had not been built if the picture was actually taken by Elec Hall, as he sold his business and moved to Buffalo, New York, some five or six years before. (Albumen print, mounted; Hall Studio, Ltn.)

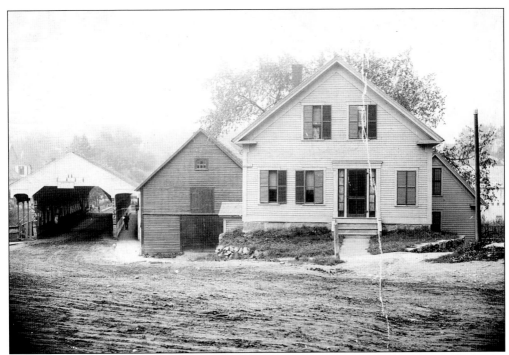

The Cottage Street Bridge and Josiah M. Ladd house, probably 1850s. The sign on the bridge warns of a $2 fine for galloping your horse on the bridge. (Gelatin silver print, possibly a copy.)

An unknown little girl of a century ago typifies for us the interest and effort Littleton has applied to the education of its young people. We have no explanation for her isolation; perhaps she has been rewarded for finishing her work by being allowed to select a book from the shelf. (Gelatin silver print.)

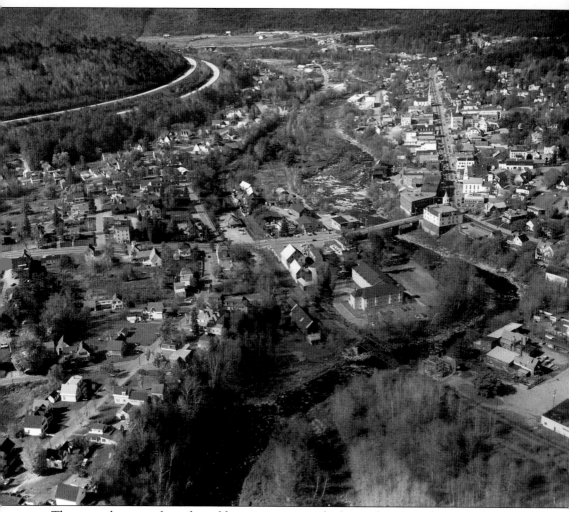

The town that grew from the wilderness is very much alive today. A modern aerial view shows Interstate 93 in the upper left curving away to the northwest, with the river winding through the town in the same course it has followed since long before the Indians fished its waters and planted maize near its shores. Main Street runs westward in a straight line at the upper right, with the Town Building at its head and the spire of the Methodist Church above to its right. The Federal Building with its small spire can be seen about half way down Main Street, with Thayers diagonally across the way, and farther down, the spires of the Congregational church. The road and river continue on to Lisbon (Gunthwait), the last stopping place of the Caswell family so long ago. (Gelatin silver print; L.F. Presby, Ltn.)